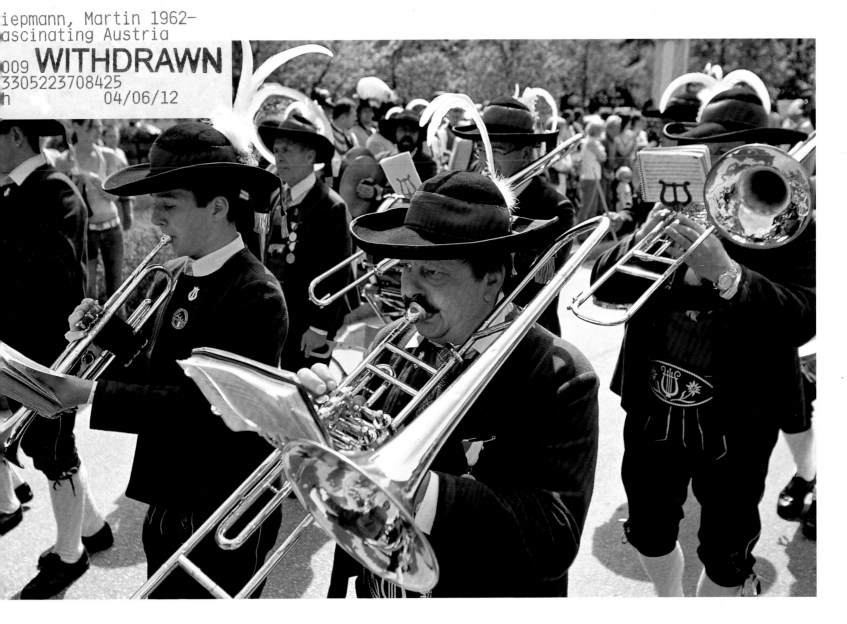

Fascinating

AUSTRIA

Photos by

Martin Siepmann

Text by

Michael Kühler

FLECHSIG

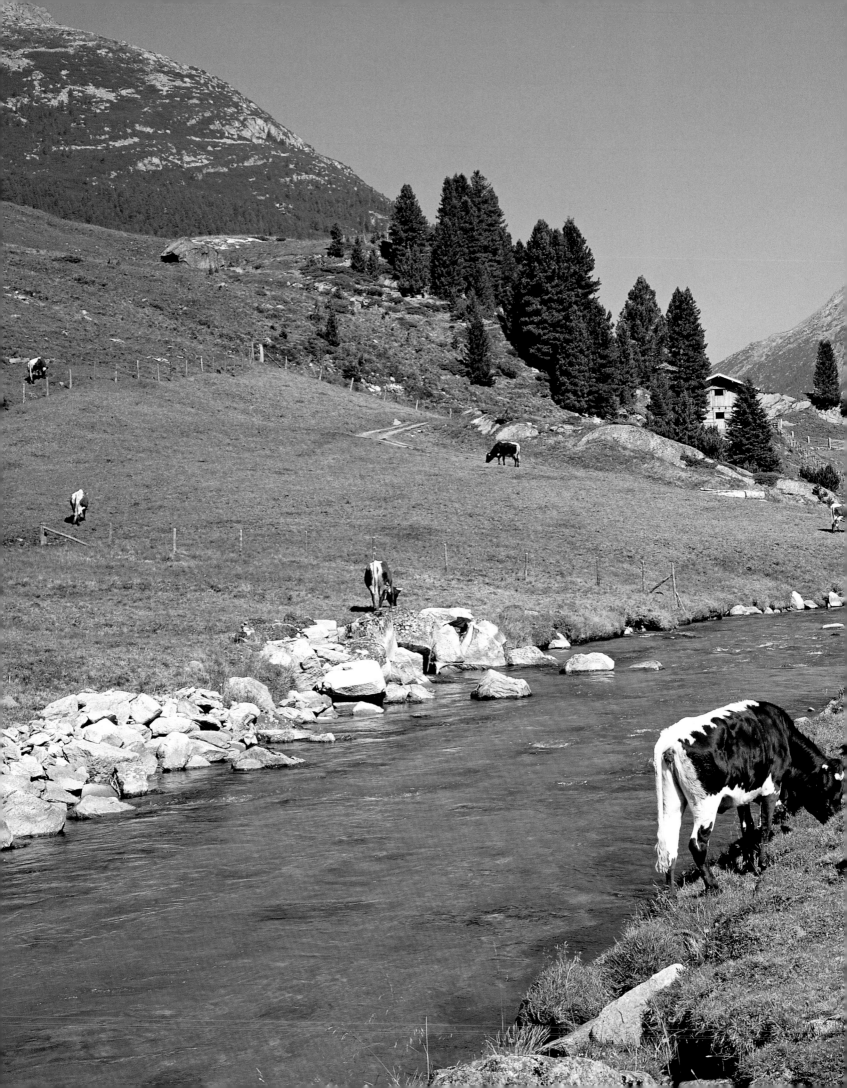

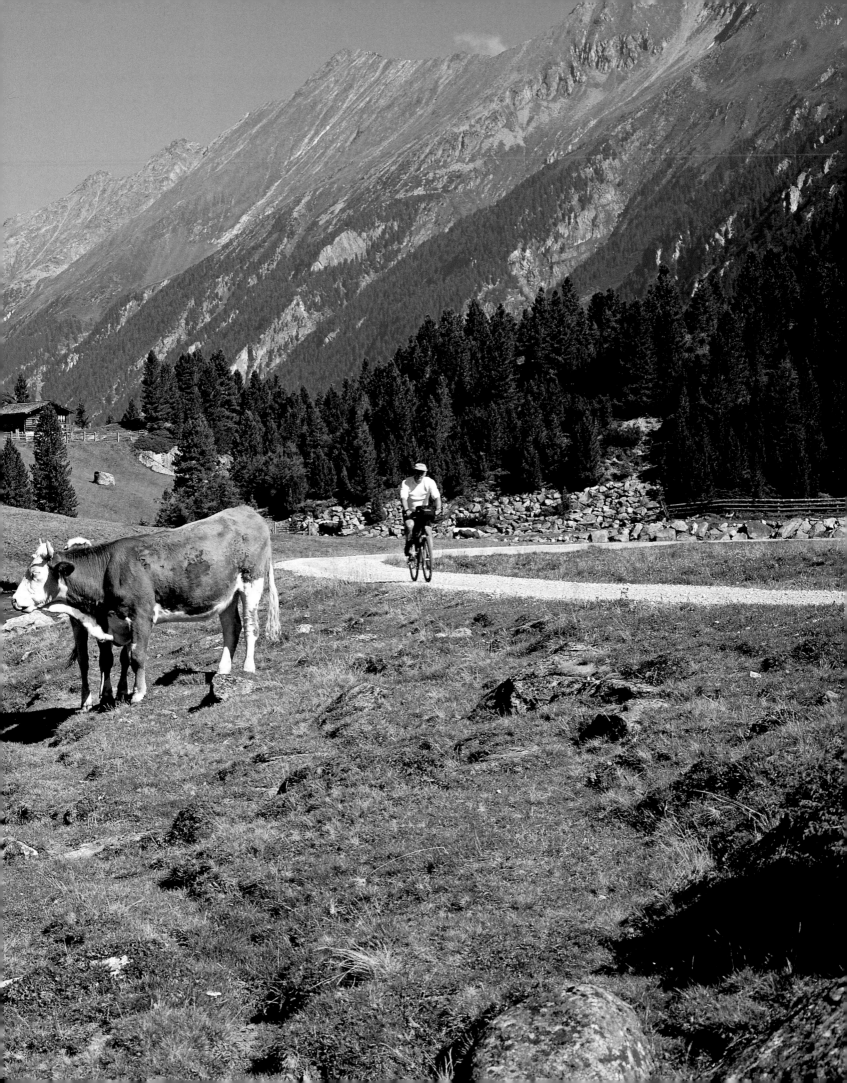

First page:
The spectacular Gauder-fest in Zell am Ziller was originally a traditional church feast. The highlight of the modern festival is the grand parade which depicts day-to-day life in and the historic events of the Zillertal. Music is also a must, with the band from Karrösten dressed up here for the occasion.

Previous double spread:
Tucked in between the Hohe Tauern and the Kitzbühel Alps, the idyllic valley of the Achen near Krimml in the southwest of the Salzburger Land is perfect hiking and cycling territory.

Right:
In c. 1890 the famous names who frequented Café Griensteidl in Vienna included architect Adolf Loos and revolutionary Leo Trotsky. The present clientele is often no less colourful than in the days of the belle époque.

Page 10/11:
Hirschegg in the valley of the Kleinwalser is as popular with hikers in summer as it is with skiers in winter. The parish church marks the spot where a stag is once said to have fought with a bear.

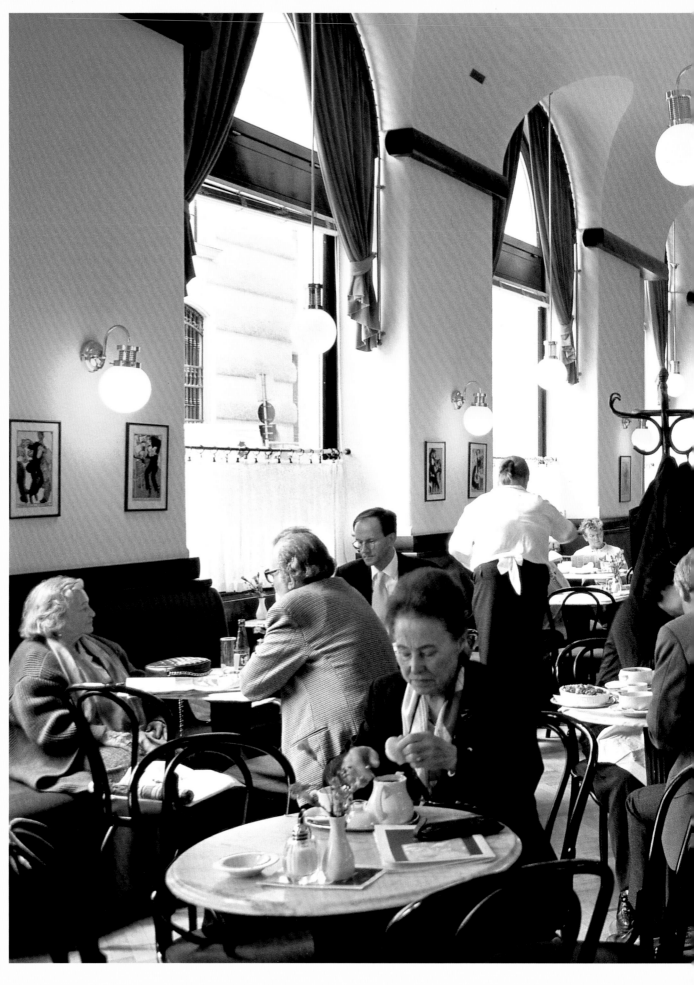

CONTENTS

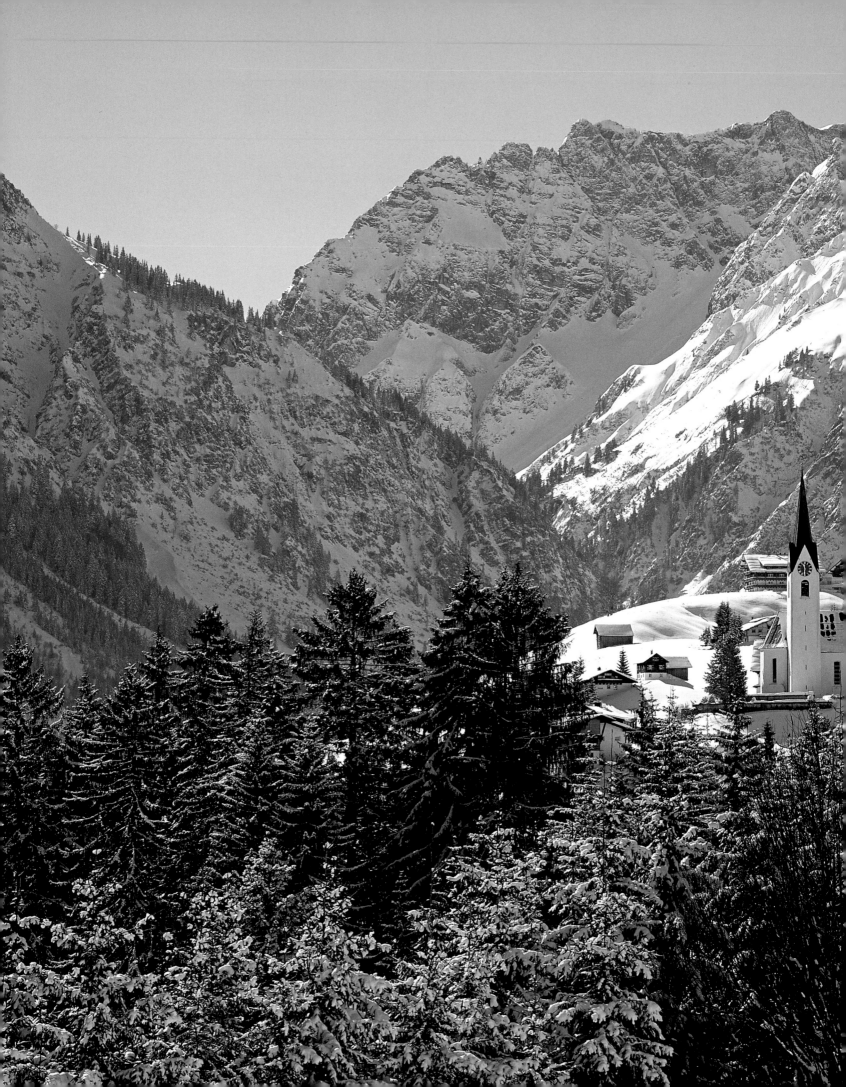

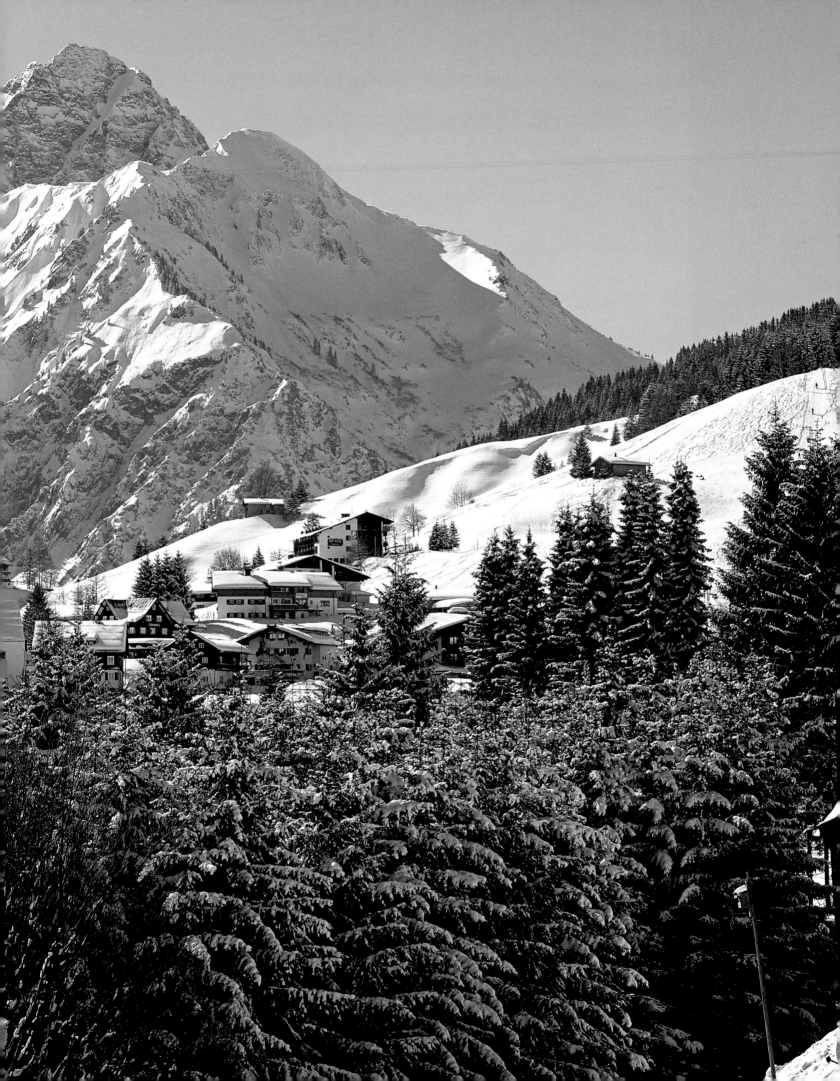

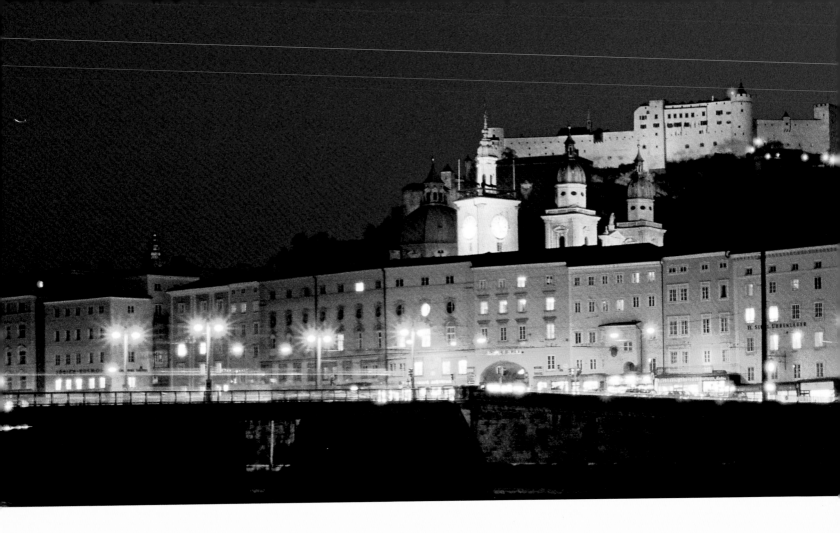

AUSTRIA – THE LAND OF WOLFGANG AMADEUS MOZART

If an Austrian on holiday is asked where he or she comes from, a simple answer usually suffices: from the land of Wolfgang Amadeus Mozart. Wunderkind Wolfgang, who in 2006 celebrated his 250th birthday, is not only famous through *The Magic Flute, Don Giovanni* and *The Marriage of Figaro*; the Hollywood film *Amadeus* has also done much to boost his popularity. His early death, which left his *Requiem* unfinished, catapulted him into the limelight posthumously. Among the latter day *homages* to the man and his music are marzipan *Mozartkugel* chocolates and the internationally acclaimed Salzburg Festspiele – with Hofmannsthal's *Everyman* as the chief attraction – all of which help to strengthen Austria's stance as the Mozartian capital of Europe. Yet the country tucked in between the perpetual glaciers of the Alps and the steppe of the Neusiedler See is much more than that. Alpine rose and edelweiss, chamois and marmots: these words awaken in many a longing for the fascinating world of the Großglockner, Hohe Tauern and South Karawanka mountains, where you can breathe in the scent of wild Alpine flowers while gazing out over majestic snow-capped peaks. Whether taking the waters in Bad Gastein, hiking the crags of the Wilder Kaiser or winding through the valley of the Ziller: whatever you do here, there's something new and unique to discover at every turn. And if the weather proves inclement, the cultural metropolises of Innsbruck, Salzburg, Graz or Vienna are never far away. At its outer reaches Austria also has its charm: in the Salzkammergut, for example, tucked in next to Germany,

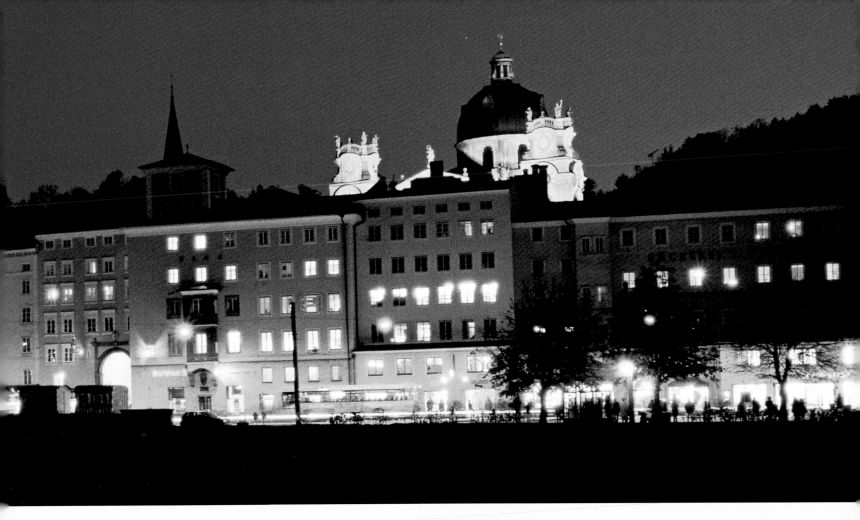

or in the Wachau, with its famous monastery at Melk and historic cultural landscape of vineyards and wine villages, of riverside forest along the banks of the Danube, of jagged rock formations crowned by the ruined castles of Aggstein, Dürnstein and Hinterhaus and Stift Göttweig, visible for miles around. Follow the course of the "beautiful blue Danube", as serenaded in Johann Strauß's famous waltz, and you end up in the former royal capital of the Habsburg emperors where, according to Karl Kraus, the streets are "paved with culture": Vienna.

Tales from Vienna and the Vienna Woods

Vienna spiralled to fame the world over largely through the concert waltzes of Johann Strauß II, such as *An der schönen blauen Donau* (The Blue Danube), *Geschichten aus dem Wienerwald* (Tales from the Vienna Woods), *Rosen aus dem Süden* (Roses from the South) and *Kaiserwalzer* (The Emperor Waltz), to name but a few. Strauß also wrote many classic operettas, including *Die Fledermaus* (The Bat), *Eine Nacht in Venedig* (A Night in Venice) and *Der Zigeunerbaron* (The Gypsy Baron). His musical prowess was inherited from his father, Johann Strauß I, who is heralded as the founder of the classic Viennese waltz and was the author of the famous *Radetzky March* and others. Many composers and musicians of renown were inspired by the imperial and royal capital to write works of the highest calibre. The chief protagonists of the Classical period in Vienna were Mozart, Joseph Haydn and Ludwig van Beethoven, who was born in Bonn but died in Vienna; the latter's *Ninth Symphony* is probably the most played work on the planet. And it's not just music which draws visitors to the Austrian capital; the old town, claimed to be one of the most beautiful city monuments in Europe, also exerts a powerful magnetism. The Gothic cathedral, the baroque Hofburg with its voluptuous cupolas and the grand boulevards of the late 19th century with their magnificent buildings, among them the town hall, state opera house and Kunsthistorisches Museum, fuse together to create a whole which is beyond compare. Antiquated forms of greeting, such as "Küss die Hand, gnädige Frau" or "Servus, Herr Hofrat", are still uttered in the many coffee houses dotted about town, where addicts of the bean are positively spoilt for choice when it comes to choosing between an *Einspänner*, *Fiaker* or *Pharisäer*. For those with an appetite for more there are the delights of Viennese cuisine to tickle your palate. You can eat your fill – and more – at a friendly *Beisl* pub or go upmarket at establishments such as the Palais Schwarzenberg. And if you fancy somewhere with a real local atmosphere, check out one of the *Heuriger* wine taverns in Grinzing, for example. As Hugo Wiener once remarked: "Where do the Viennese go where they're happy? To the *Heuriger*! Where do the Viennese go where they're sad? To the *Heuriger*!" No other European metropolis grows and makes as much wine within its bounds as Vienna. And if you're still vaguely upright after trying some of it, a trip on Vienna's legendary landmark then awaits: the Ferris wheel at the

Looking out across the Salzach at night, with the Rathaus and cathedral on the left and the collegiate church on the right. The transportation of salt along the river made the town rich and also gave it its name: Salzburg.

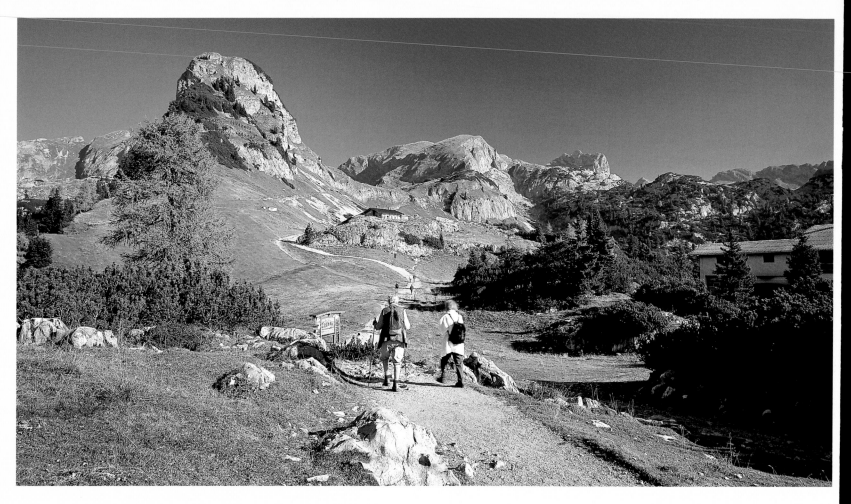

If you don't feel up to the climb, the Rofan cable railway will gently transport you up to the Erfurter Hütte from whence you can take a gentle stroll to the summit of the Gschöllkopf (2,039 metres/ 6,690 feet above sea level).

Prater funfair. From the top there are wonderful views out across the Danube and Vienna as far as the Vienna Woods.

"You, fortunate Austria, marry!"

For a long time the royal seat of the Habsburgs wasn't actually in Vienna. Emperor Friedrich III, descended from the line of Styria, chose to reside in the Viennese Neustadt and in Graz. It was his son, "last knight" Emperor Maximilian I, who through his skilled politics of marriage managed to secure world power for the Habsburg dynasty. At the age of 16 he and his father were guests at the famous Landshuter Hochzeit of 1475 which went down in the annals of history as the most sumptuous royal wedding of the Late Middle Ages. Possibly inspired by the married bliss he witnessed on this occasion he was later prompted to proclaim: "Let others wage war; you, fortunate Austria, marry!" Maximilian's grandson, Karl V, took him at his word and by 1519 at the pinnacle of the Habsburgs' might he had managed to accumulate a number of titles; he was not only "Holy Roman king and emperor, archduke of Austria, duke of Styria and Carinthia" et cetera but also "Lord in Asia and Africa". Even if not all of these titles are founded on fact, their number at least is impressive.

Leaving Vienna for Graz we come across the Semmering railway, which even at the time of its conception was praised for creating a perfect symbiosis between technological advance and the natural environment. Like

Schloss Schönbrunn, Vienna's old town, Neusiedler See and the historic centre of Graz itself the Semmeringbahn is now a UNESCO World Heritage Site; such a density of famous places is rare. Styria is popular with fans of folk music for the Styrian harmonica which is one of the chief instruments used in this form of musicmaking. In Graz, the Styrian capital, one of Austria's most famous – and not always uncontroversial – contemporary writers ditched his degree course in law to dedicate himself to the fine arts: Peter Handke. Many 20th-century literati who have lived and worked in Austria have become household names, among them Stefan Zweig, Franz Kafka (who died in Vienna) and Handke himself. Helmut Qualtinger is another *artiste* to have become imprinted on minds of many; in the golden age of Viennese cabaret during the 1950s he erected a satirical monument to the petty bourgeois of Austria in "Herr Karl". And way beyond the national boundaries impressive pictures of Vienna were beamed onto cinema screens across the globe in the movie *The Third Man*, whose unmistakable zither melody is among the greatest film music of all time.

Strada del Sole

During the 1950s it became fashionable to spend a week or two on the strands of one of Austria's glorious lakes. Many a holidaymaker bound for the sunny climes of Italy plumped instead for the Wörthersee in Carinthia with its positively Mediterranean temperatures. Aus-

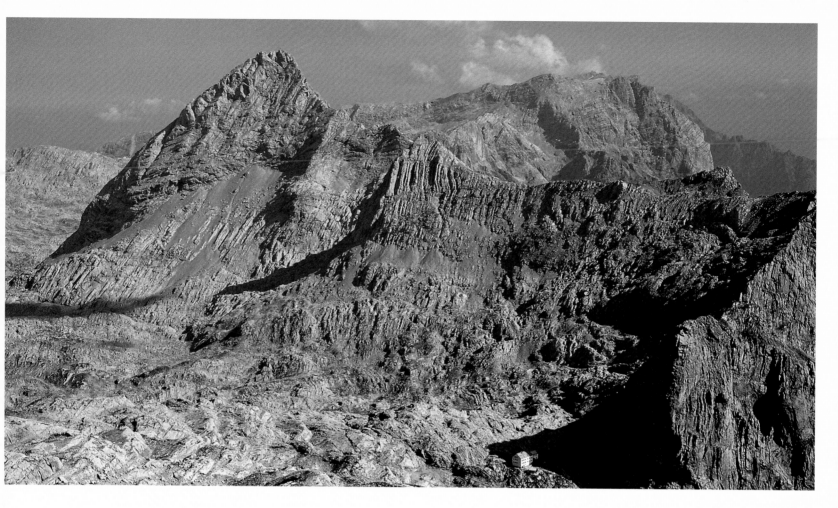

The Riemansshaus Alpine chalet in the Steinernes Meer can be reached on foot in four hours from Saalfelden or Maria Alm. For practised mountaineers it's a good place to set off on tours of the peaks, one of them being the Breithorn shown here (2,504 metres/ 8,215 feet).

tria's ability to pull the (tourist) crowds was no doubt increased by the event of the filmed operetta, such as *Die Csardasfürstin* (The Gypsy Princess) starring Marika Rökk, or by the unforgettable Hans Moser who effused charm and wit in a voice which can only be described as nasal. And then there was the roaring international success of Ralph Benatzky's operetta *Im Weißen Rössl am Wolfgangsee* (White Horse Inn) which has a fond army of followers even today. The restaurant of the same name still exists and is one of the many places you can experience Austria's proverbial hospitality first hand. *Jause* (cold platter) and *Jagertee* (alcoholic tea) at an Alpine hut in the Hohe Tauern, freshly baked bread from a wood-fired stove, milk, butter and cheese from brown cows grazing fertile mountain pastures... This is what hikers feast themselves on from spring to autumn, with skiers looking forward to a warm fire burning in the hearth in winter. Precipitous ski runs, half-pipes and fun parks with snow guaranteed can be found near the Dachstein, the Großglockner and in Tirol. The cold Adriatic bora often brings more snow here to the south of Austria than to the northern Alps. The Arlberg, Zillertal and Kitzbühel are famous for their excellently prepared pistes and – more importantly for some – for good après-ski. The Ötztal is also internationally famous – not least for its recent discovery of Ötzi, the ancient mummy preserved in ice and now on display in Bolzano. There's now an Ötzi village and even a DJ called Ötzi, whose hit *Ich bin der Anton aus Tirol* is guaranteed to get

any après-ski party positively fizzing. Other ditties of renown are the poetic and often pert chansons of Rainhard Fendrich, such as *Strada del Sole*, *Es lebe der Sport* and *Macho, Macho*; there's even such a thing as Alpine rock, made popular by the likes of Hubert von Goisern and his band the Alpinkatzen.

The Strada del Sole is a tourist route running from Tirol across the Brenner Pass down into Italy. Despite – or maybe because of – the huge amount of transit traffic rolling along it each year many decide to stop off en route or even spend a holiday here. There's plenty to see and do; one place to visit is the Swarovski Kristallwelten (world of crystals) near Innsbruck, an underground labyrinth of glass and light featuring the largest and smallest crystal gem in the world, designed by none other than André Heller. A more poignant experience can be had at the museum cemetery in Hagau whose headstones are often inscribed with witty tributes to the deceased, such as "Here lies Joanna Birdsong who tweeted her way through life". This and much more epitomises the morbid sense of humour shared by Austrians as a whole and by the Viennese and Tiroleans in particular, a fascination with death which is not just harboured by the country's famous satirists but also reflected in its songs and folk art.

The Goldenes Dachl – Duke Friedrich "of the empty pocket"

No holiday in Tirol would be complete without a stroll through Innsbruck. Prestigious dwellings built in the

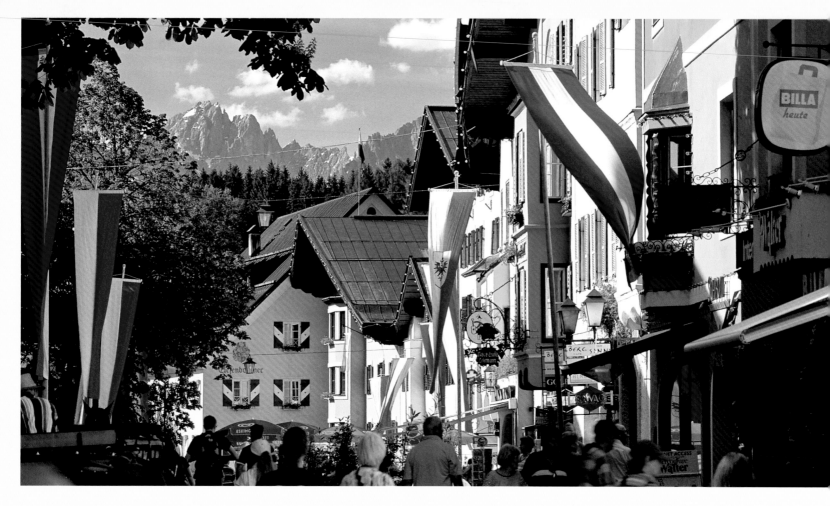

Above:
The world-famous winter resort of Kitzbühel is not only where the Hahnenkamm Race is held; it's also popular with the big names in sport, politics, the arts, commerce and show business.

Page 18/19:
Painter Angelika Kauffmann (1741–1807) is fondly commemorated in the little village of Schwarzenberg where her father came from. Rural idyll and hospitality are also writ large, with visitors sure of a hearty welcome at the Gasthof Adler, depicted here.

Inn-Salzach style, complete with generous arcades, bear witness to the wealth and riches of the city's former inhabitants, as does the Hofburg or imperial palace, the seat of the Habsburgs under Emperor Maximilian I. In celebration of his marriage to Bianca Maria Sforza the palace oriel was given a golden roof, now one of the most photographed motifs in town. An alternative story behind the making of the Goldenes Dachl claims it was built by Duke Friedrich IV, he "of the empty pocket", who wanted to prove that his financial situation wasn't as dire as his subjects believed…

Innsbruck is indeed rich – in beautiful scenery, set against the impressive backdrop of the Karwendel Range and many other snow-capped peaks, such as the Patscherkofel. Riches of a very different kind can also be found in Vorarlberg. Not only are traditional folk art and folk music held in high regard here; in the Bregenzer Wald the typical wooden shingle house is finding new forms of expression. By way of contrast, tucked away in a side valley near Dornbirn, the biggest collection of Rolls Royce Phantoms has created quite a stir. Some are commandeered for use by visitors to the famous Bregenz Festspiele – who, if they've managed to secure tickets well in advance, have to be careful when driving up to the stage on the water's edge that they don't roll their Roller straight into Lake Constance. Like the car, the festivals in both Bregenz and Salzburg are of the highest quality – greatly contributing to the fame of Austria as a cultural metropolis in the heart of Europe.

Right:
Stephansplatz snakes around the base of Vienna's local landmark, the Stephansdom. Beneath the glazed tiles of the cathedral's mighty roof the square is a hive of activity in summer, packed with tourists, locals and street performers entertaining the crowds.

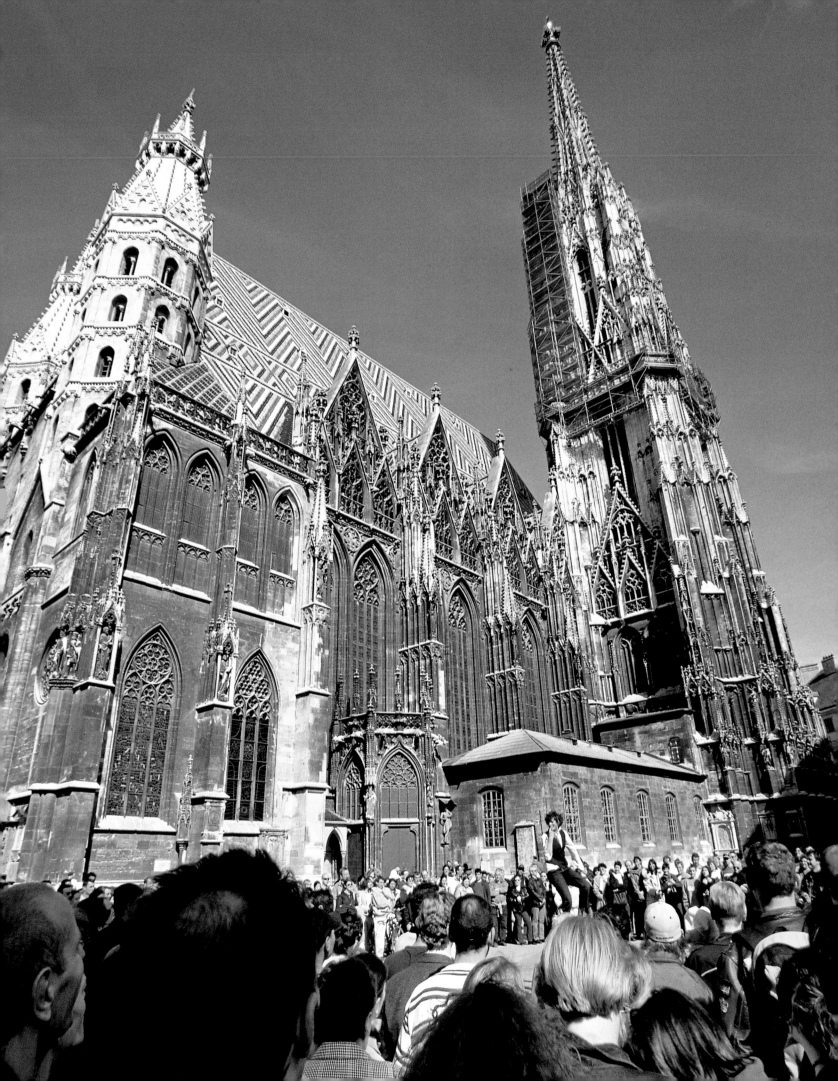

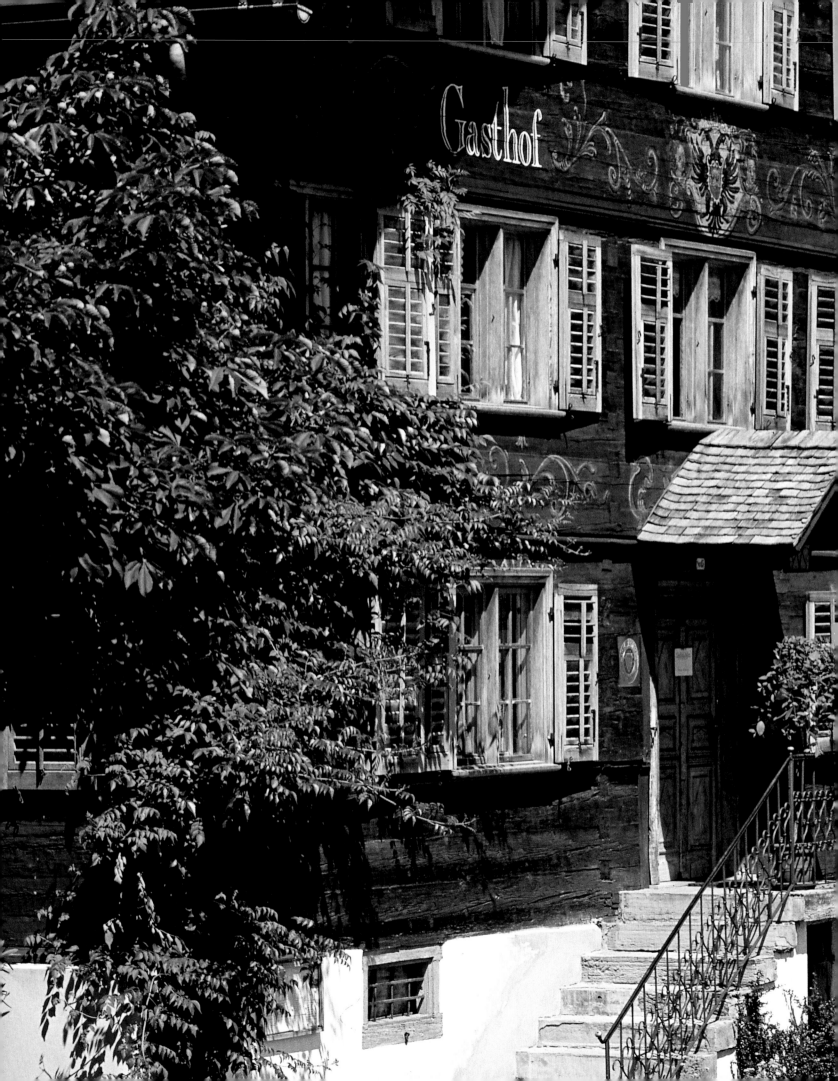

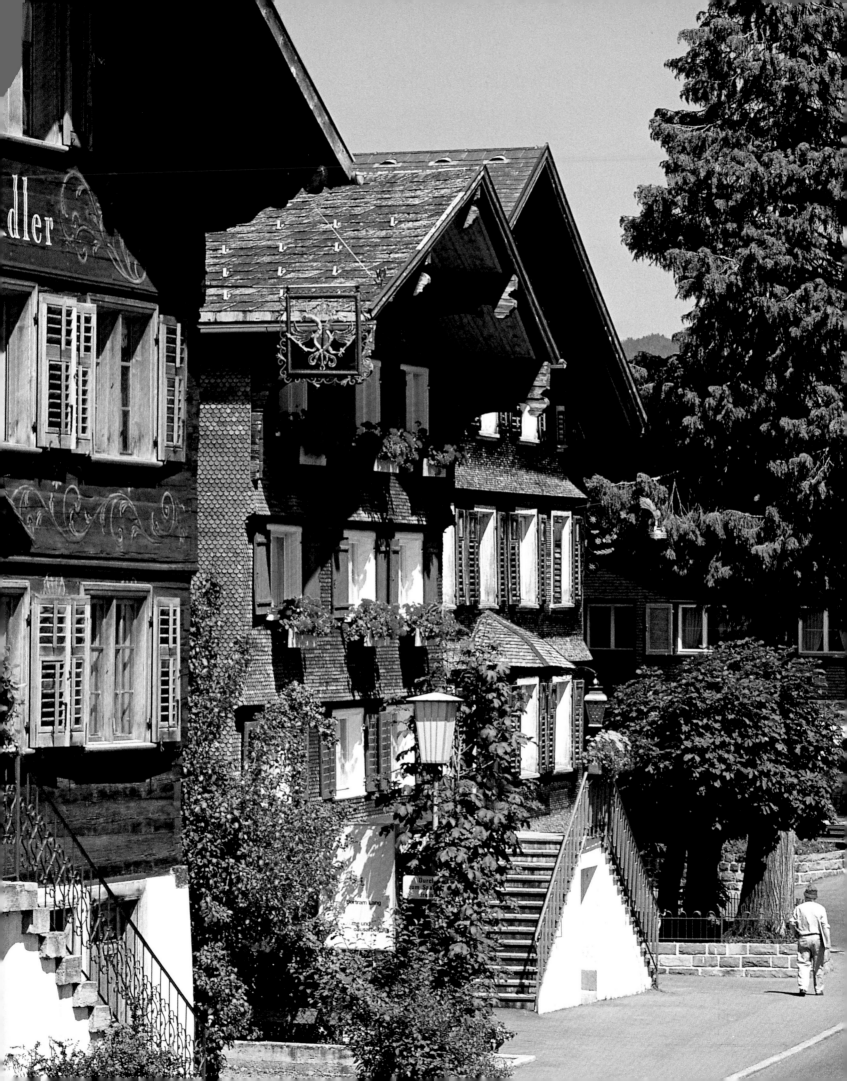

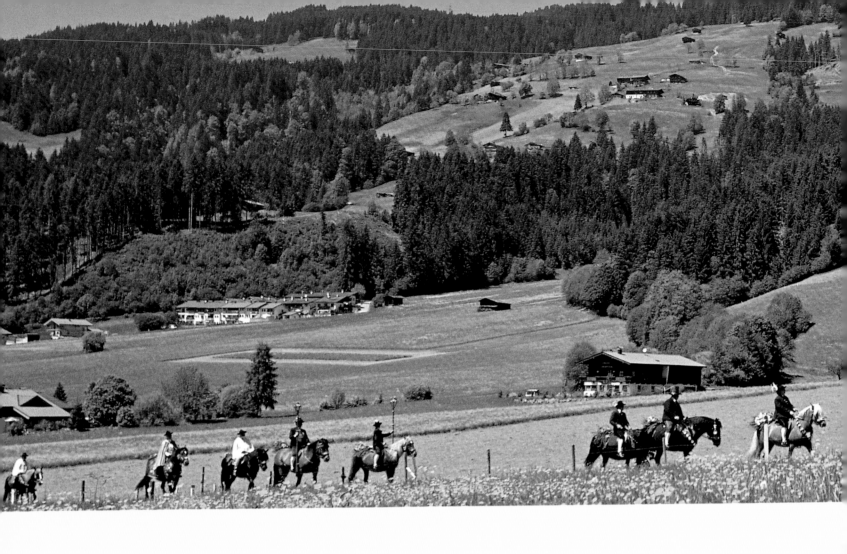

FROM VORARLBERG TO TIROL

One of the most scenic approaches to Austria is from the Swabian Sea – or Lake Constance, to give it its official English designation. The Bregenzer Wald which borders the lake has produced many names of renown; creator of the baroque in Southern Germany, Peter Thumb, came from Bezau and the architectural Beer family lived in Au. Painter Angelika Kauffmann even had commissions from royal households – which was practically unheard of for a female artist during the 18th century. Alois Negrelli from Moldelbe, whose plans formed the basis of the Suez Canal, was also local, as was Hermann Gmeiner, the founder of SOS Children's Villages famous throughout the world. Gütle in Dornbirn is also worth a visit, where amid much pomp and circumstance Emperor Franz Josef I operated the first telephone of the Austria-Hungarian Monarchy in 1881. The complex now houses the Rolls Royce Museum.

Whether reclining in a posh car, clad in sporty leathers on a motorbike or – for the very daring – peddling furiously on a racing cycle, passes like the Fern Pass, Resia Pass, Furkajoch and countless others can pose a challenge to both man and machine. They also, however, promise you an unforgettable journey through the spectacular landscapes of Vorarlberg and Tirol.

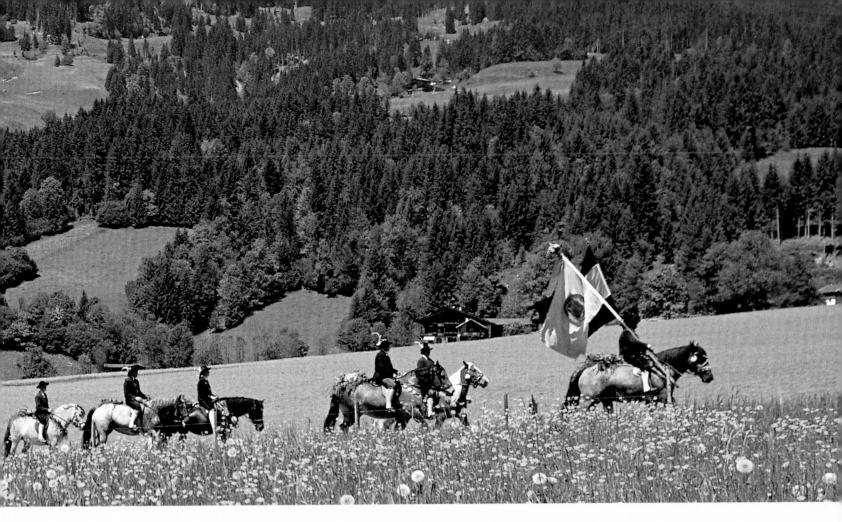

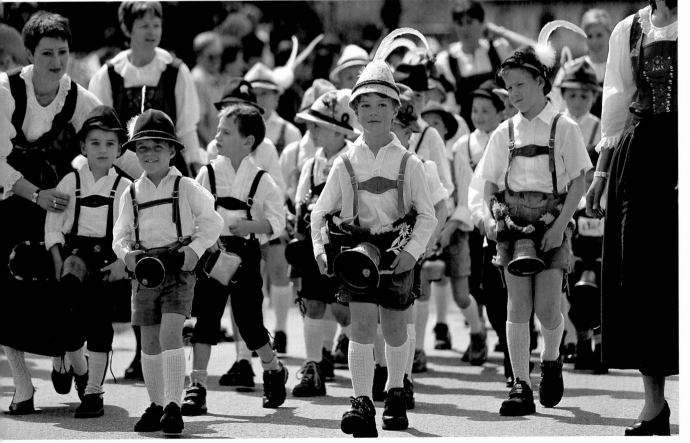

Above:
According to legend the Corpus Christi Antlaßritt in Brixental dates back to an oath sworn during the Thirty Years' War. The heathen elements to the parade suggest that its origins are much older, however.

Left:
Among the most popular participants in Zell am Ziller's Gauderfest are the "Grasausläuter", the young boys who head the parade. Amidst much ringing of cowbells they herald the beginning of the grazing season. They are accompanied by King Gambrinus astride an enormous barrel of beer, ensuring that the occasion is suitably celebrated.

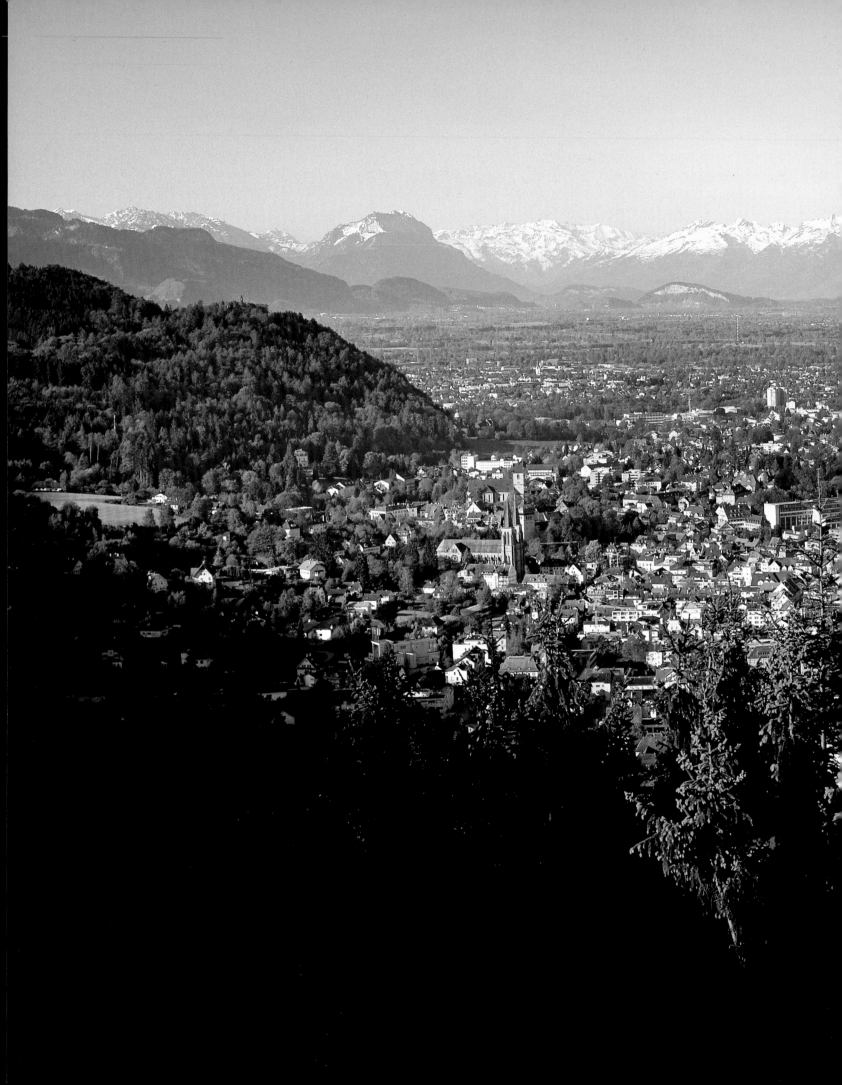

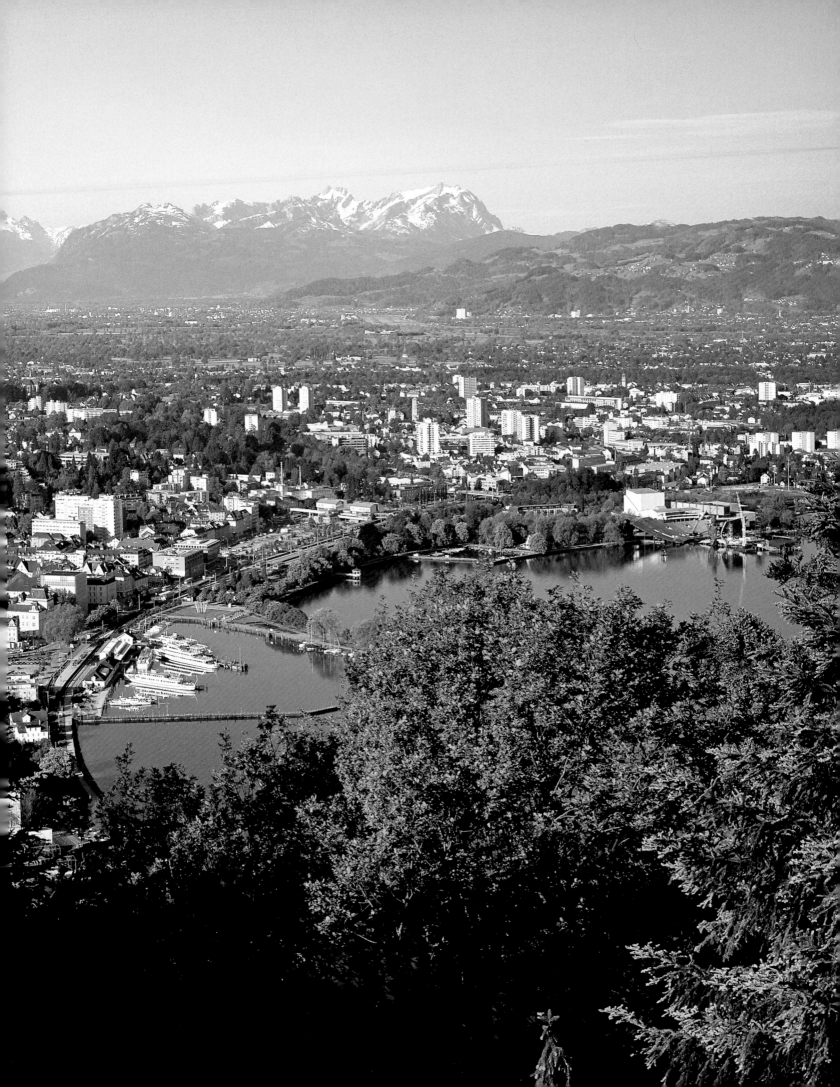

Page 22/23:
Bregenz, clinging to the shores of Lake Constance and squeezed in between Austria, Switzerland and Germany, is famous for its lakeside festival. It also has magnificent views out across the lake, with the snow-capped peaks of the Alps in the distance.

From the harbour in Bregenz both scheduled services and pleasure trips are operated. Some of the boats offer morning brunches and evening dances for an unforgettable cruise across the expansive waters of Lake Constance.

The Cistercian monastery of Mehrerau west of Bregenz was founded by the Benedictines in 1097. The Cistercian brothers from Wettingen in the Swiss Aargau were forced to leave their home in 1841; a new monastic educational institution was subsequently opened here in 1854 which is still operating as a private boarding school.

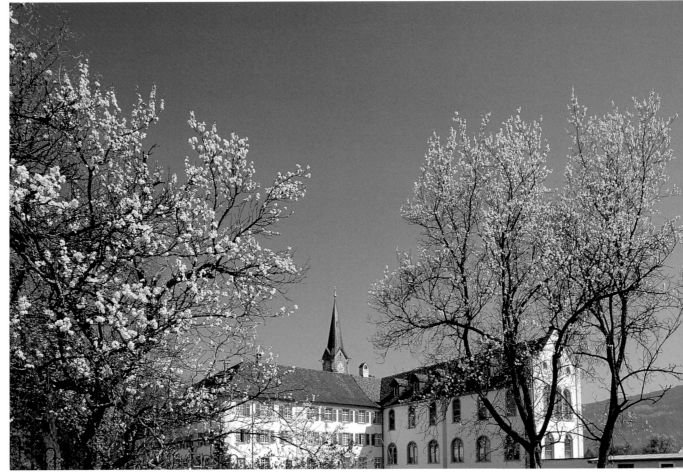

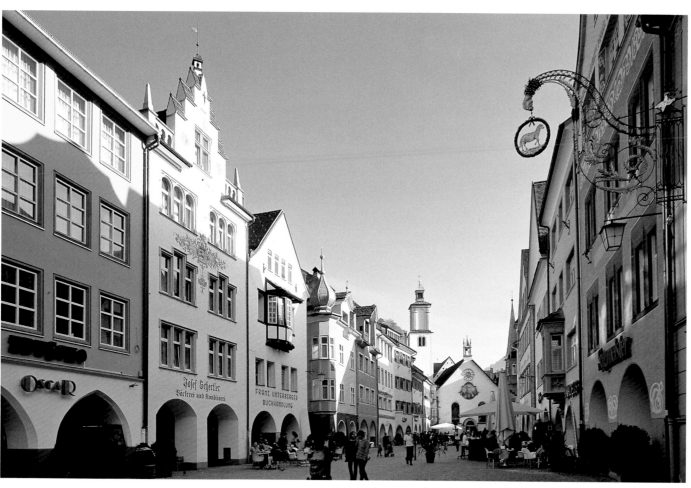

Feldkirch borders on the principality of Liechtenstein and is the westernmost town in Austria. Wonderful patrician residences line the market place, now spared the busy through traffic thanks to the building of the Bregenz to Innsbruck motorway and the Arlberg Tunnel.

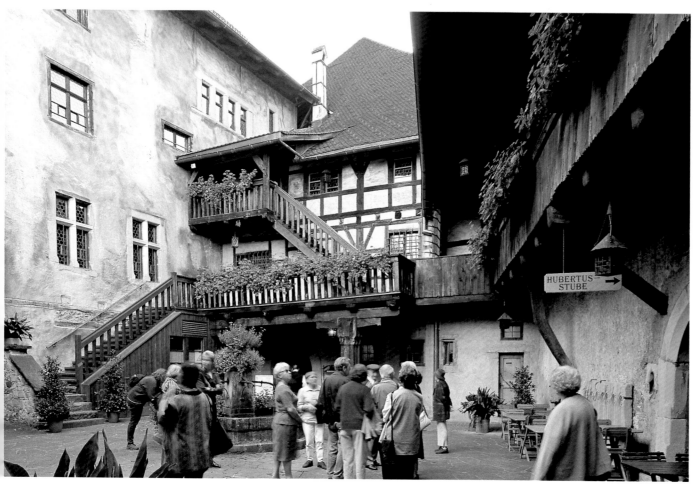

From the beginning of the 13th to the 14th centuries the Schattenburg in Feldkirch was home to the counts of Montfort. The castle has a splendid inner bailey around which run sturdy wooden ramparts; the museum also boasts a wooden Romanesque crucifix dating back to c. 1250.

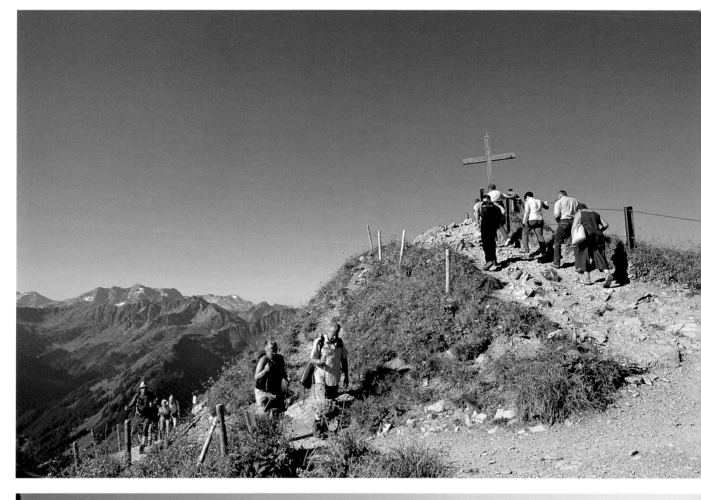

Surrounded by high mountains, the only way to get to the Kleinwalsertal in the Austrian province of Vorarlberg is from neighbouring Germany. One of the peaks, the Walmendinger Horn (1,993 metres/ 6,539 feet), can be more easily reached by cable car.

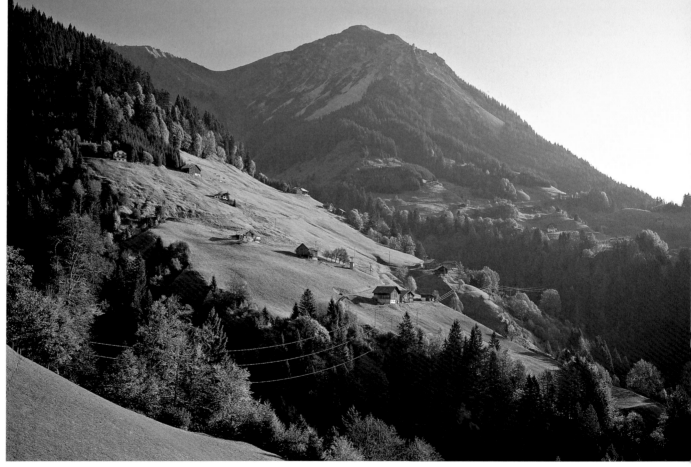

From Fontanella in the Großes Walsertal there are glorious views out across lush Alpine pastures and the rolling slopes of Blasenka Mountain. Fontanella covers an area of 32 square kilometres (12 square miles) and borders on Sonntag to the south and southeast and the parish of Au to the northeast.

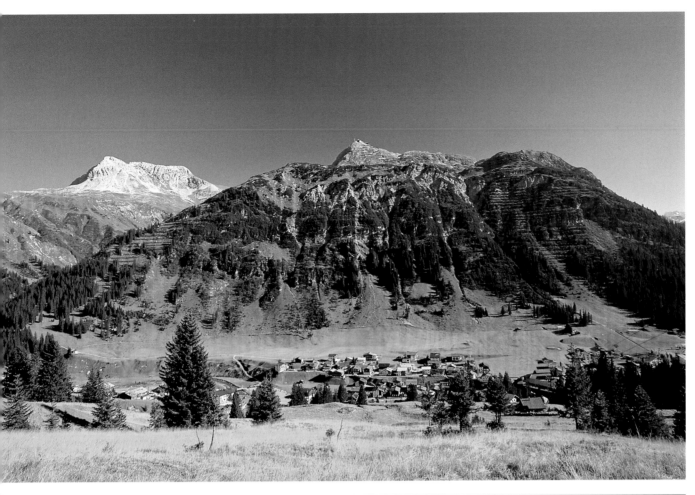

The Arlberg region is lauded as the birthplace of winter sports, with the resorts of St Anton, Lech, Zürs and Stuben famous the world over. Many of the lifts also operate in summer, sparing hikers the long climb to the area's magnificent summits.

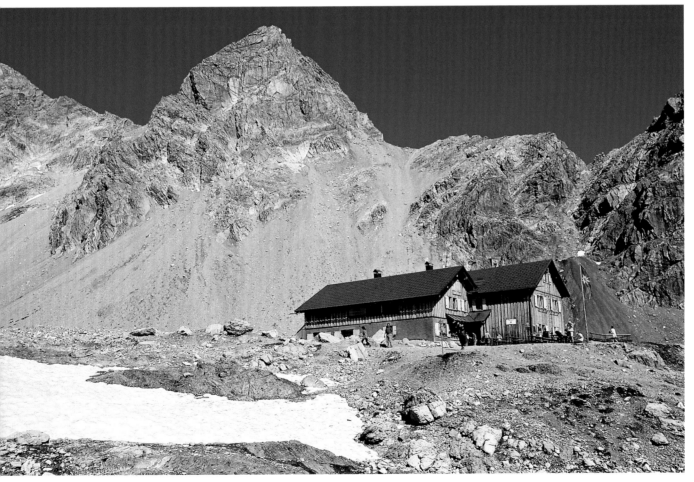

From the Totalphütte at 2,385 metres (7,825 feet) above sea level it's a three-hour hike to the Schesaplana, the highest peak in the Rhätikon. The chalet has recently been granted an environmental order of merit by the province of Vorarlberg and is open from mid June to the beginning of October.

Page 28/29:
Ellmau at the foot of the Wilder Kaiser is popular with holidaymakers in both summer and winter. One original way of spending your vacation here is to go hiking at the Achlhof which organises the transportation of your luggage by packhorse.

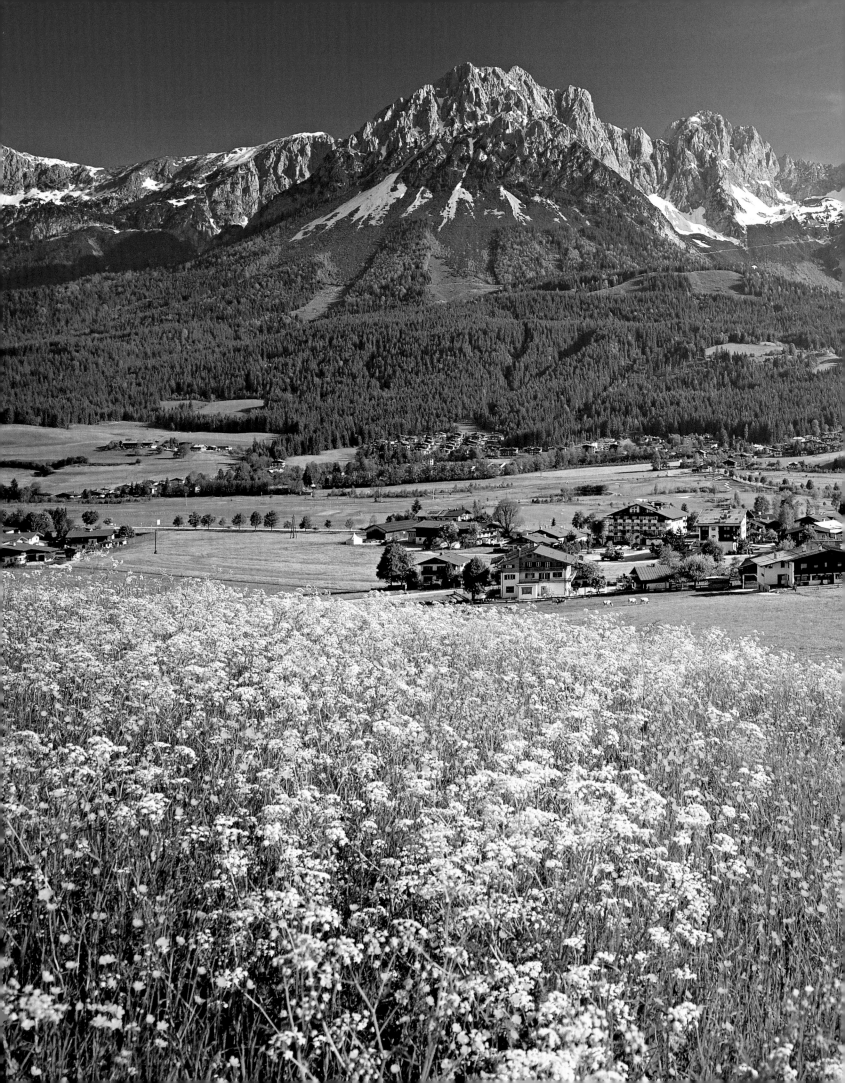

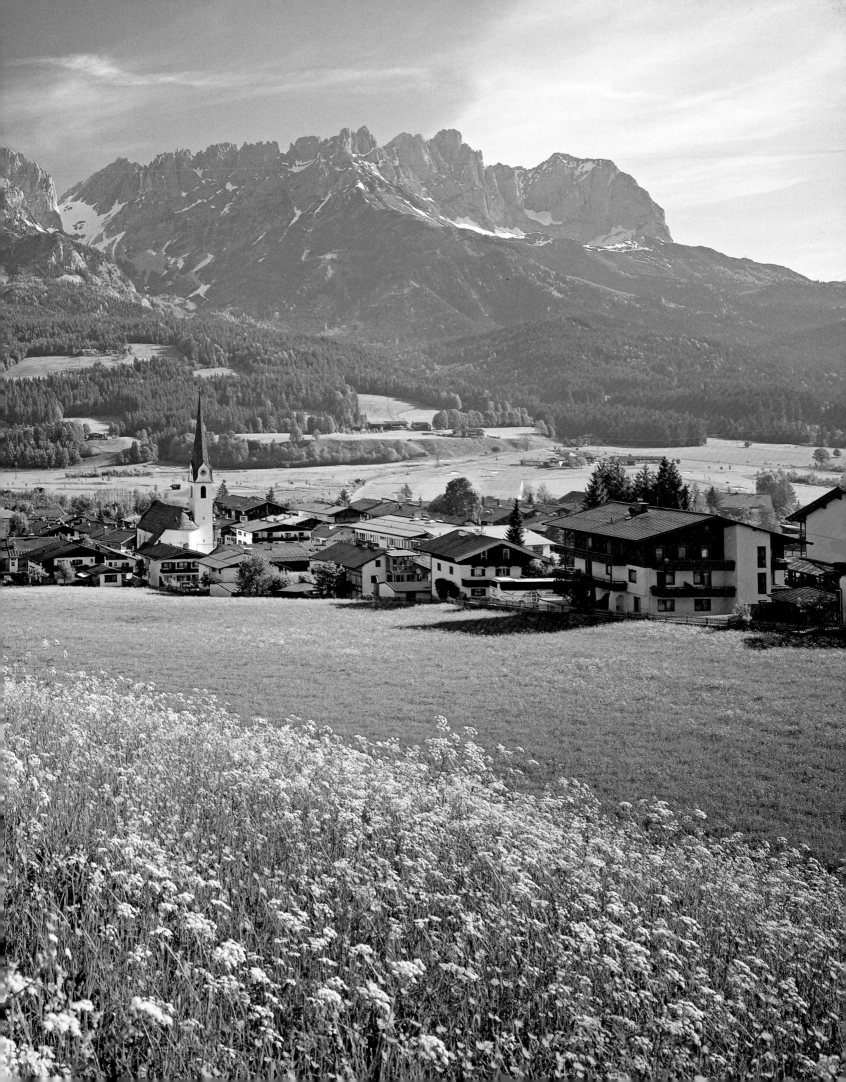

From the Stadtturm in Innsbruck there are good views of the Goldenes Dachl, cathedral and Karwendel Range. The oriel with its roof of gilt shingles was once the royal box of the Habsburgs who, seated comfortably inside, could watch the goings-on on Stadtplatz without leaving the palace.

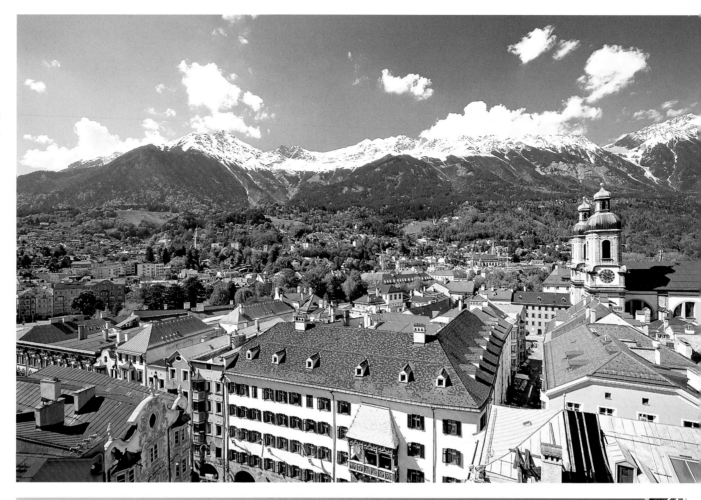

The Annasäule outside the Neues Rathaus was erected in 1706 to celebrate the withdrawal of Bavarian troops on St Anne's Day three years previously. Maria-Theresien-Straße leading off from the column is the main aorta of the Tirolean capital.

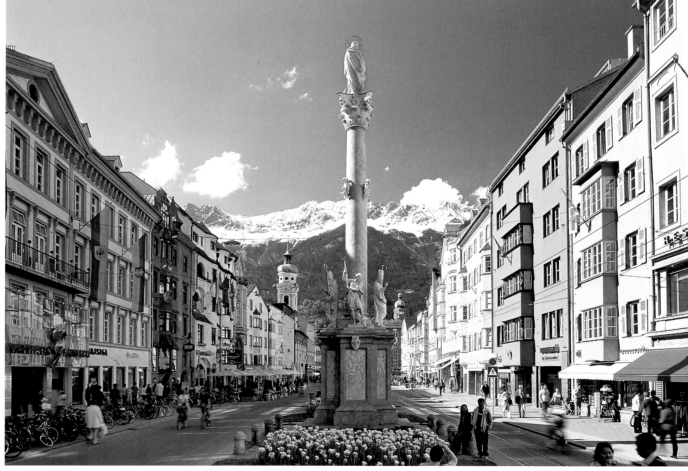

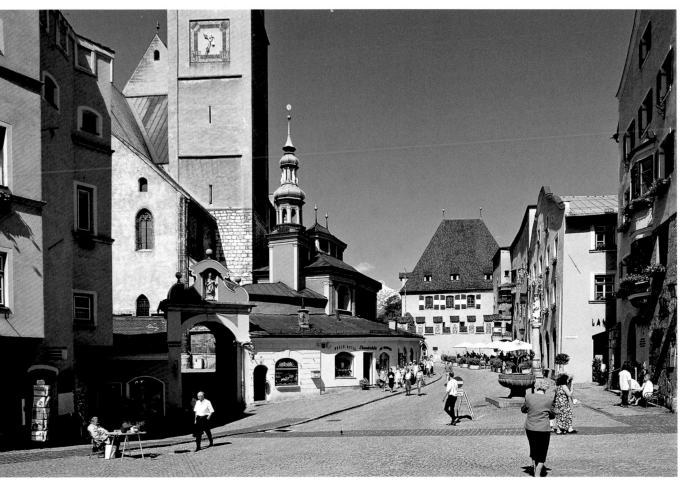

The little town of Hall in Tirol prospered in the days of salt mining; the towering facades of the old town still bear witness to the wealth and confidence of its citizens. The Ratssaal and panelled chambers of the mayor in the medieval Rathaus at the end of the square are open to the public.

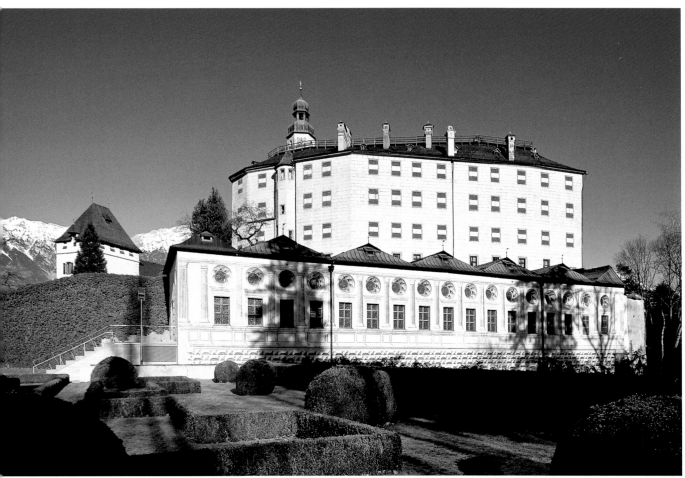

During the 16th century Archduke Ferdinand II had Schloss Ambras built near Innsbruck for his wife Philippine Welser. The palace is well worth visiting for its luxurious bathroom and Spanischer Saal or Spanish Room (1570/1571), one of the best examples of interior Renaissance design in Central Europe.

From the Kufstein Haus atop Kufstein's local Alp, the Pendling, there are mountains as far as the eye can see on a fine day like this. And if you simply can't tear yourself away from the glorious panorama of the Kaiser Range, Hohe Tauern and Zillertal Alps, the chalet also has rooms …

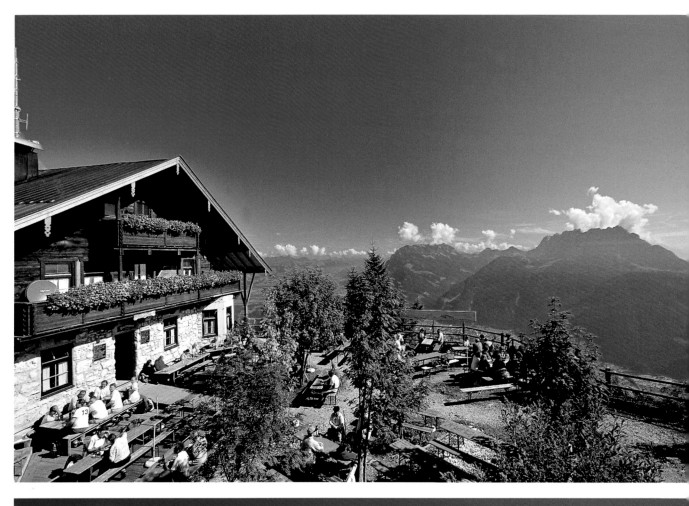

From the top of the Bären-kopf in the Karwendel Range you can look down onto the brilliant blue waters of the Achensee. 9 kilometres (5 1/2 miles) long, 1 kilometre (1/2 mile) wide and 133 metres (436 feet) deep, the lake is the largest and probably also the most beautiful lake in Tirol.

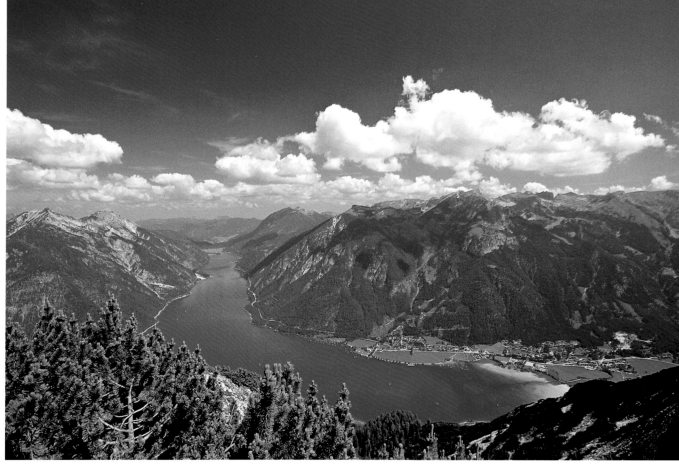

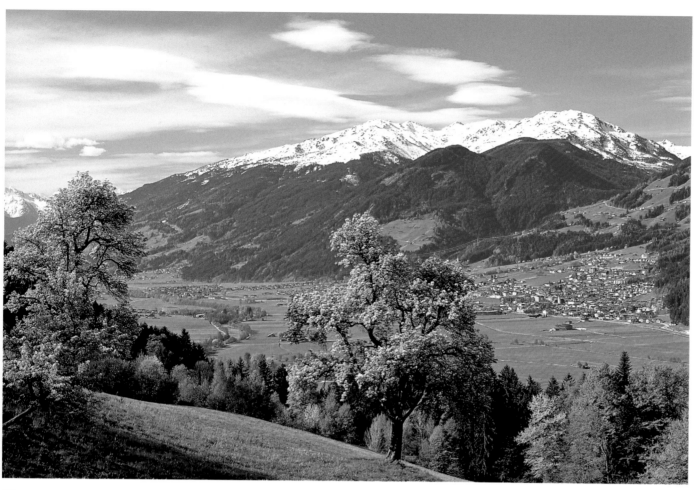

The area around Fügen in the Zillertal was inhabited as early as in 1200 BC and was first officially mentioned under the name of Fugine in c. 1130. The town comes complete with castle which was turned into a school boarding house for boys in 1926.

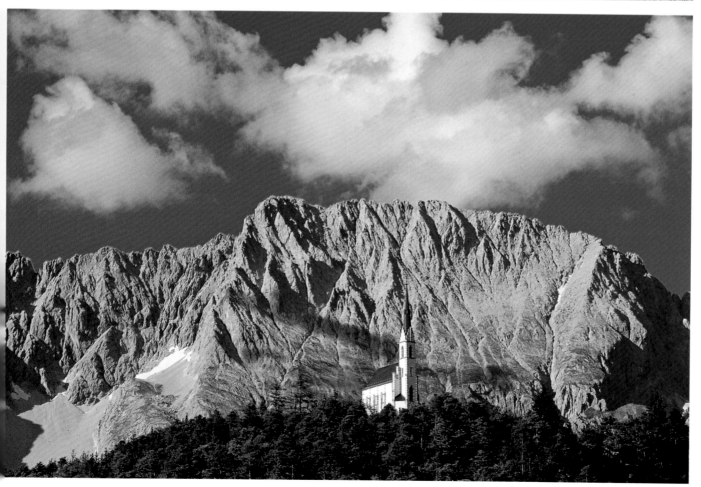

Maria Locherboden in the Mieming Range can be reached from the Inn Valley. The little church has always been a popular place of pilgrimage for the Tiroleans. Its holy relic is a copy of a painting by Lukas Cranach which is now in the cathedral in Innsbruck.

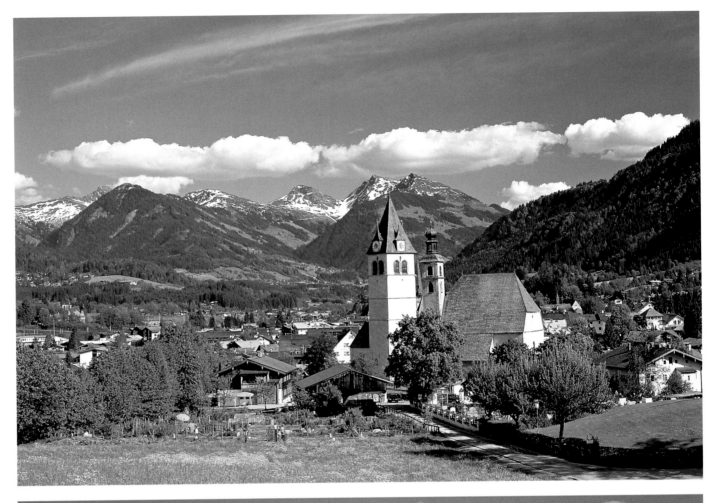

Kitzbühel in Tirol straddles a ridge in the valley of the Leuken, at the base of which lap the waters of the Gänsbach and Ehrenbach. The two rivers have their source in the Hahnen-kamm Mountains and flow into the Kitzbüheler Ache.

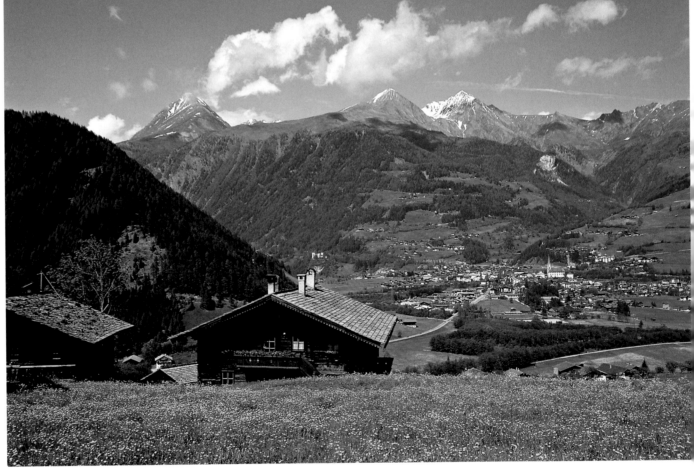

Matrei in East Tirol enjoys a scenic setting at the southern end of the Hohe Tauern. Via the Felber-Tauern Tunnel the town is now easily reached from the north. The area is great for easy walks and also provides access to the highest peaks in Austria, these being the Groß-glockner (3,797 metres/ 12,458 feet) and the Groß-venediger (3,674 metres/ 12,054 feet).

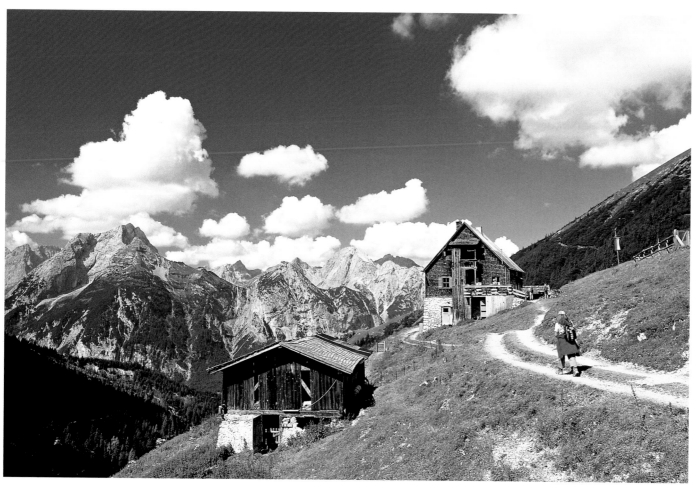

The Karwendel Alpine park is the most important area of natural conservation in Tirol. Bang in the middle is the Plumsjochhütte, a mountain chalet-cum-pub which can also be reached by mountain bike.

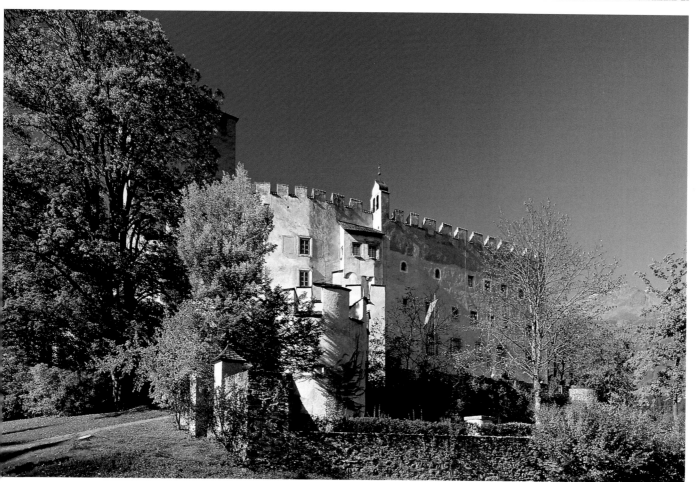

Schloss Bruck in Lienz now houses the Osttiroler Heimatmuseum, a museum of local interest which among other things has works by artist Franz Defregger (1835–1921) on display. His genre paintings of everyday farming life in Tirol stand in marked contrast to the elaborately staged historical and social portraits by his teacher Karl Theodor von Piloty.

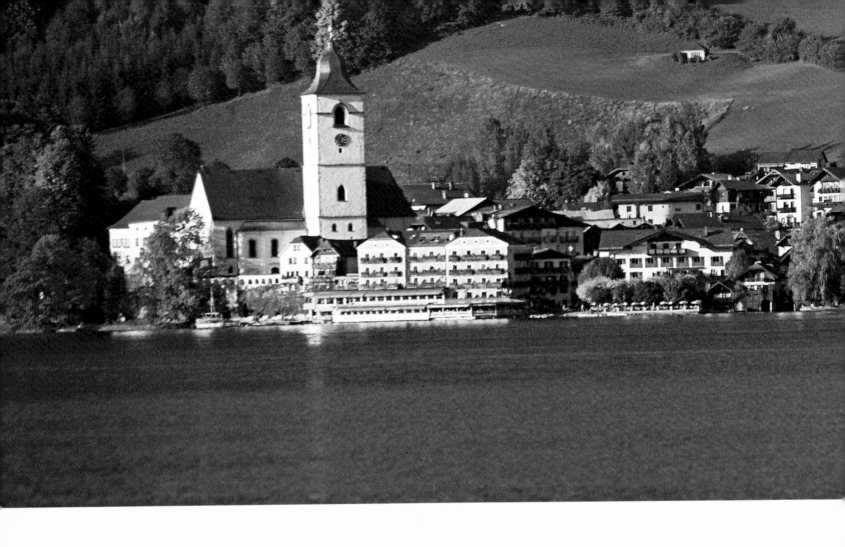

From Upper Austria to Carinthia

The Rupertiwinkel near Salzburg, now in Bavaria in Germany, was long in the hands of the prince-bishops of Salzburg – with the Innviertel between the Salzach, Inn, Danube and Hausruck part of Bavaria for centuries. Oberndorf was where the dulcet tones of *Silent Night* were first heard and Steyr is also strongly associated with Christmas; during Advent a special post office near the Christkindl church stamps letters from all over the world with a festive postmark.

The Innviertel in Upper Austria is an area of undulating hills. The Mühlviertel and Lower Austrian Waldviertel are rougher in character and the elevations higher. The foothills of the Hungarian plains creep into the Weinviertel near Vienna. South of the Danube the land moves upwards, culminating in the giddy peaks of the Hohe Tauern and the highest mountain in Austria, the Großglockner. The high summits protect the Klagenfurt Basin from cold north winds, warming the lakes of the Ossiacher See, Millstätter See and Wörthersee for swimmers in summer.

Water is not only important to the region's many holiday-makers; in the days of yore it was a major means of transport. Salt, the "white gold" of the Alps, was shipped along the Inn and Salzach and made Salzburg a very rich town indeed. Small barges known as *Ulmer Schachtel* (literally: "boxes from the city of Ulm") ferried people along the Danube as far afield as Vienna, Budapest and beyond.

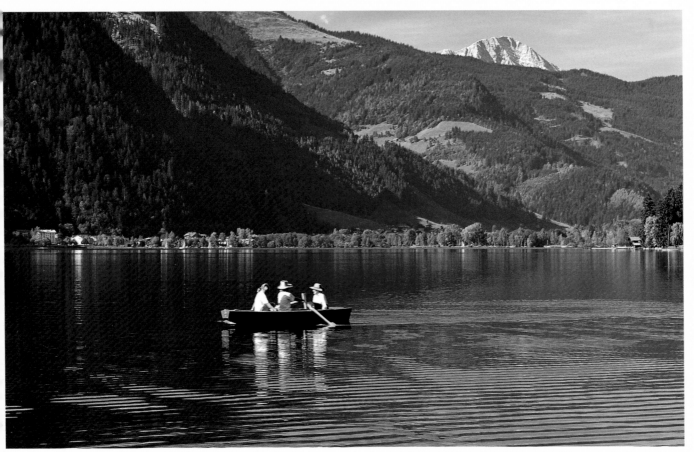

Above:
The Wolfgangsee is the most famous lake in the Salzkammergut. The town of St Wolfgang and especially the Weißes Rössl Hotel were made popular the world over by Ralph Benatzky's operetta "Im weißen Rössl am Wolfgangsee" (White Horse Inn).

Left:
A lift runs up from the Zeller See in the Pinzgau to the mountain of Schmittenhöhe (1,965 metres/ 6,447 feet) where you can embark on a lengthy but relatively flat six to seven-hour hike along the ridge – complete with fantastic views.

The Dreifaltigkeitssäule outside the 17th-century town hall on the main square in Linz is dedicated to the Holy Trinity. Made from Untersberg marble, the column was erected in 1723 in thanks for the town being spared the horrors of war and the bubonic plague.

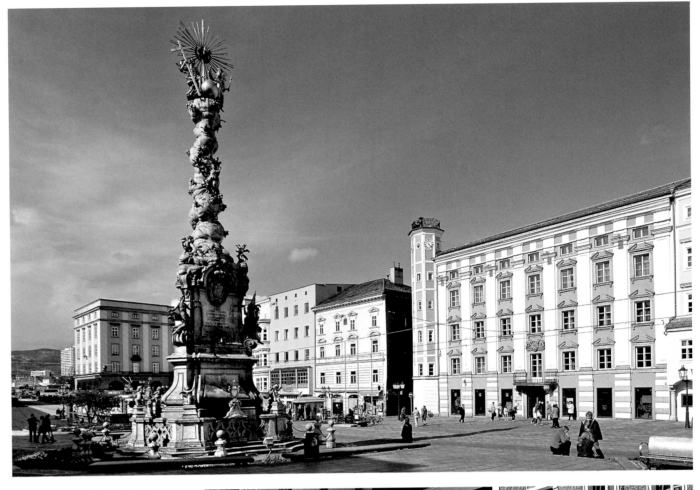

The Mondsee is one of the warmest lakes in the Salzkammergut; the town of the same name on its shores is also enticing with its picturesque market place. Pile dwellings from the late Stone Age (between 3600 and 3300 BC) excavated locally have given rise to the term Mondsee Culture.

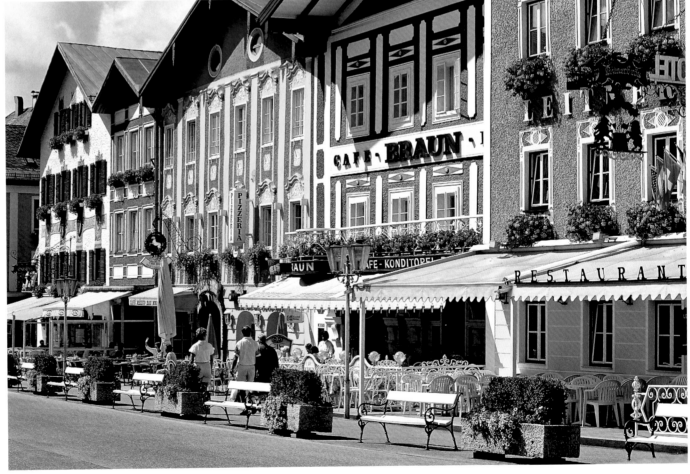

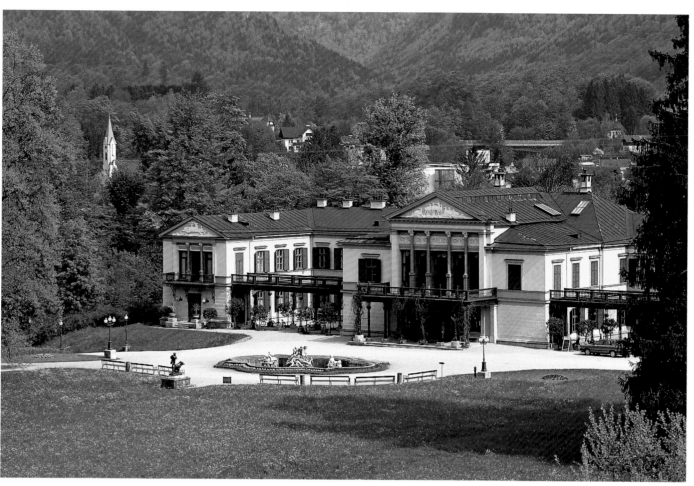

Archduchess Sophie gave her son Franz Joseph I and his wife Elisabeth, otherwise known as Sissi, the Kaiservilla in Bad Ischgl as a wedding present and summer residence. The emperor spent around sixty summers here.

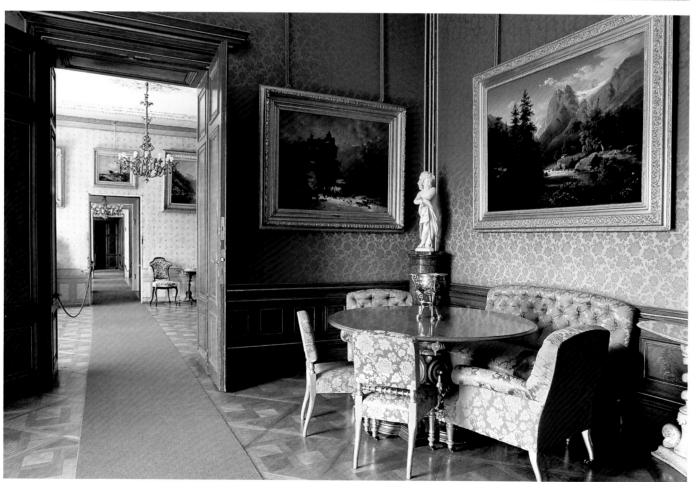

Empress Elisabeth had a gymnasium installed at the Kaiservilla. If free she preferred to do her daily workout in the Roter Salon, however, when two big oval mirrors were hung at each end of the room.

The castle of Ort in Gmunden on the Traunsee used to belong to Archduke Johann Salvator (or Johann Orth, hence the name). It's built on a tiny island in the lake and is linked to the mainland – via the Toskana peninsular – by a long wooden bridge. The country seat on the peninsular was once the property of a Tuscan collateral line of the Habsburg family.

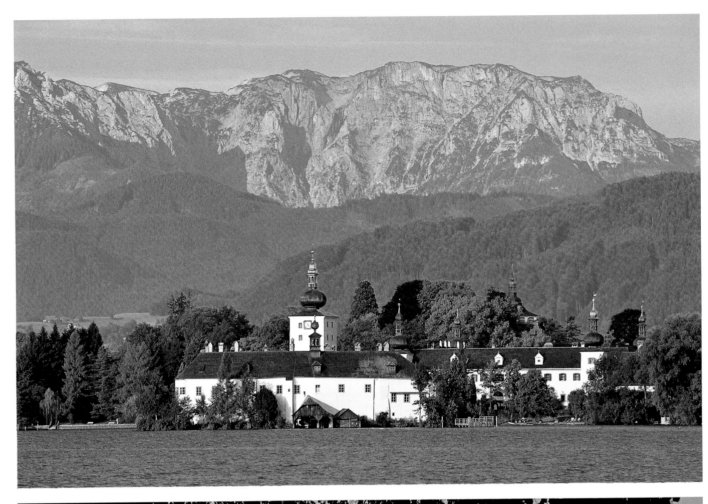

20 kilometres (12 miles) long, up to three kilometres (two miles) wide and 171 metres (561 feet) deep, the Attersee is the biggest lake in the Austrian Alps. Cosy little farming villages cling to its shores. Shown here is Schloss Kammer where concerts are staged in the Rittersaal or old knights' hall.

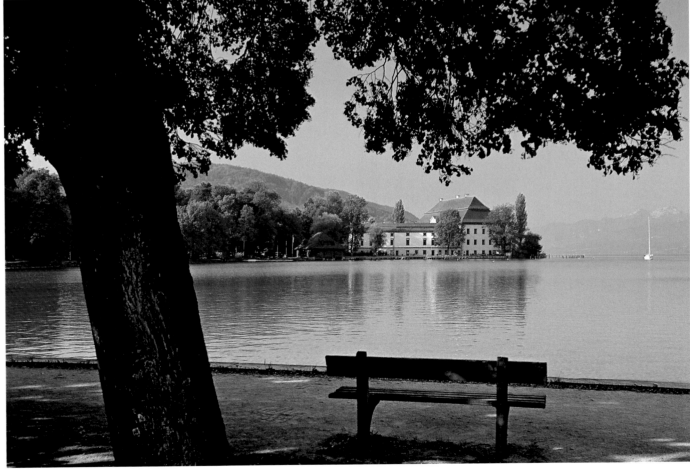

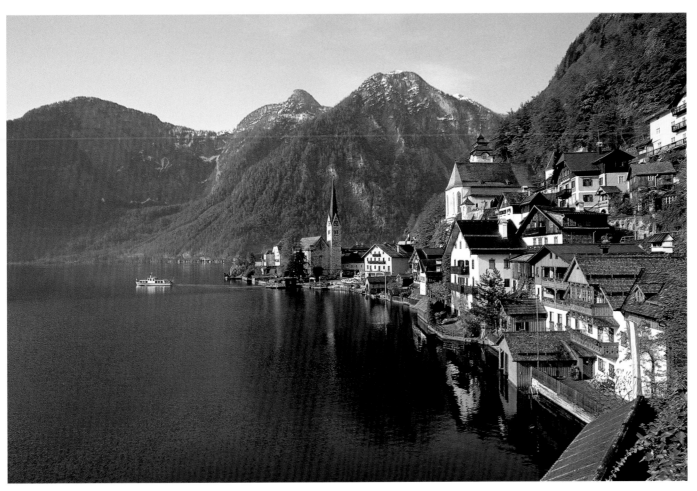

Hallstatt on the lake of the same name in the Salzkammergut. Important finds excavated here by Johann Georg Ramsauer from 1846 onwards gave rise to the term Hallstatt Period in reference to the first stage of the European Iron Age (8th to 4th century BC). This important region around Hallstatt and the Dachstein Massif was made a UNESCO World Heritage Site in 1997.

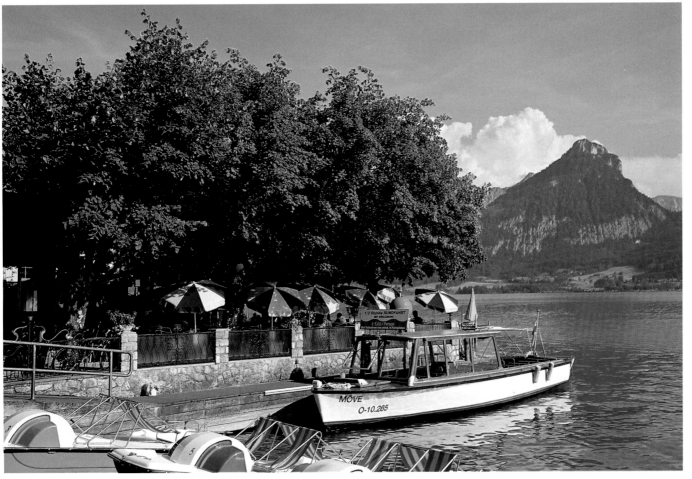

The Wolfgangsee is popular with both anglers and divers – with various water skiing, sailing and surfing activities on offer for the more active. If you prefer to take things a little slower, a trip on one of the lake's pleasure boats is highly recommended.

Page 42/43:
Steyr, situated at the confluence of the Steyr and Enns rivers, is the hub of Austria's iron and steel industry. To the left of St Michael's with its twin steeples is the old hospital church. Another famous place of worship nearby – especially around Christmas – is the Christkindl pilgrimage chapel.

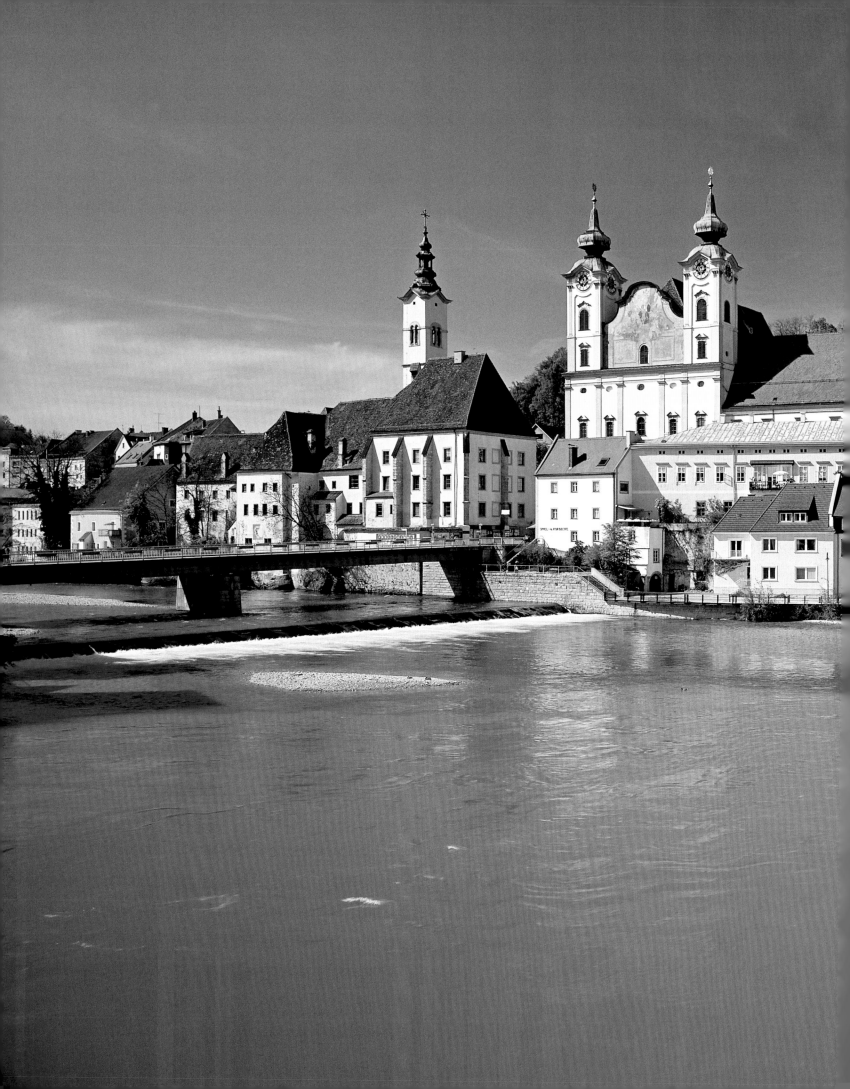

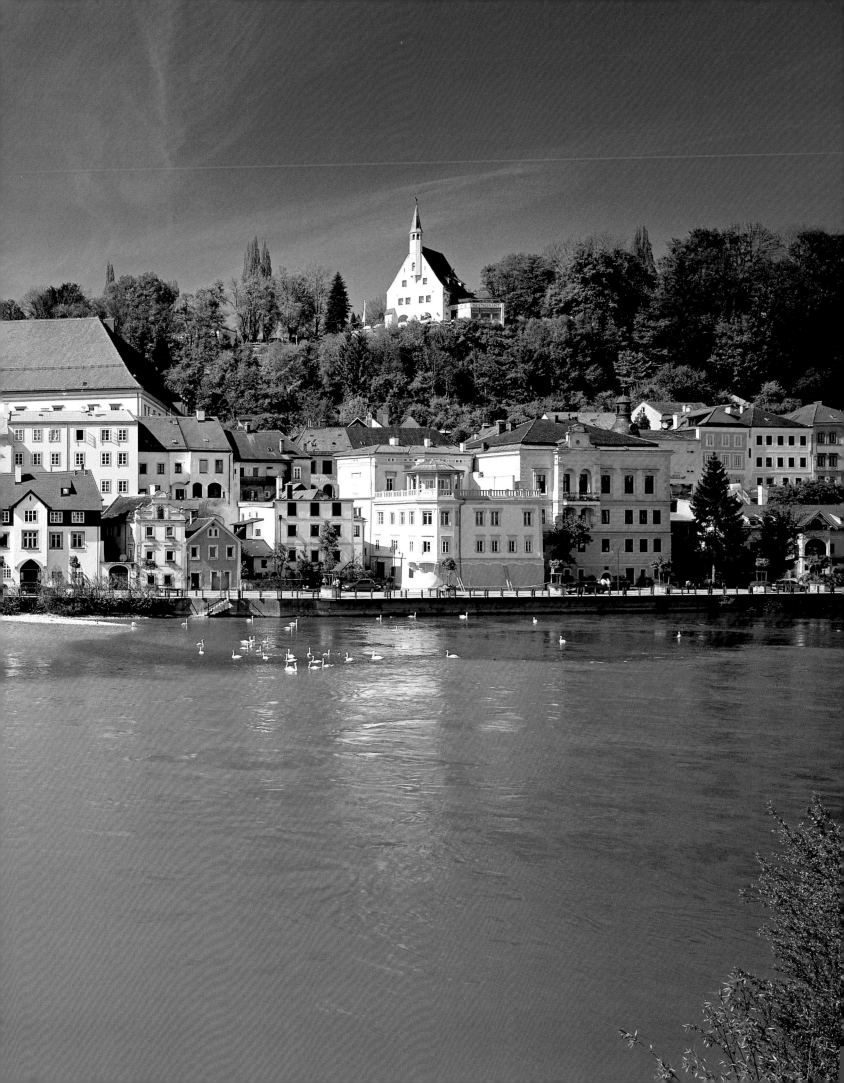

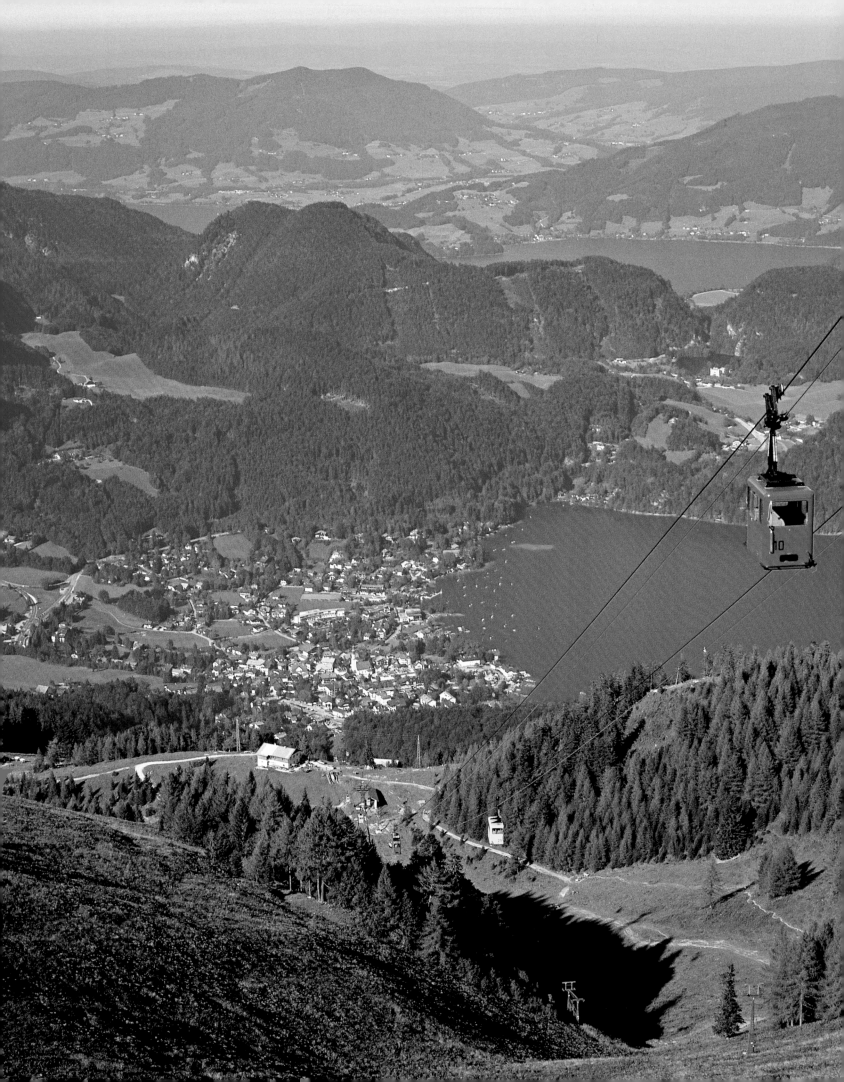

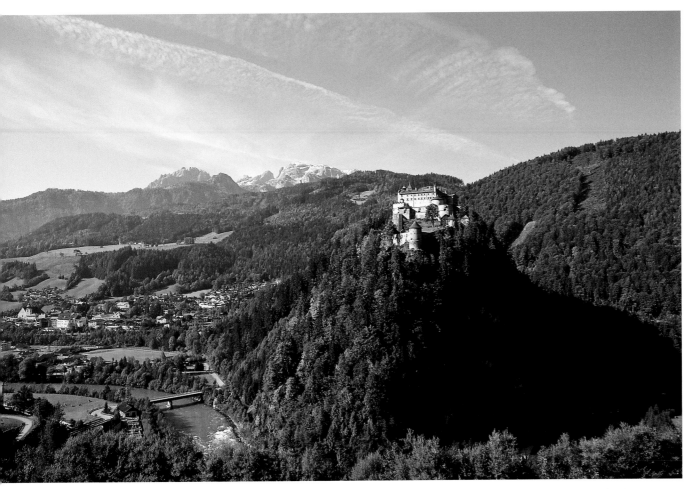

Left page:
It takes just fifteen minutes to reach the summit of the Zwölferhorn with the cable railway from St Gilgen am Wolfgangsee. Once at the top there are wonderful vistas, summer and winter hiking trails and the promise of hours of fun for skiers, snowboarders and paragliders.

Burg Hohenwerfen, north of Werfen in the Pongau, is visible for miles around. Archbishop Gebhard had the fortress built in 1077 to protect him from the armies of the emperor. Not far from Werfen is the Eisriesenwelt, one of the biggest known ice caverns in the area which is open all summer.

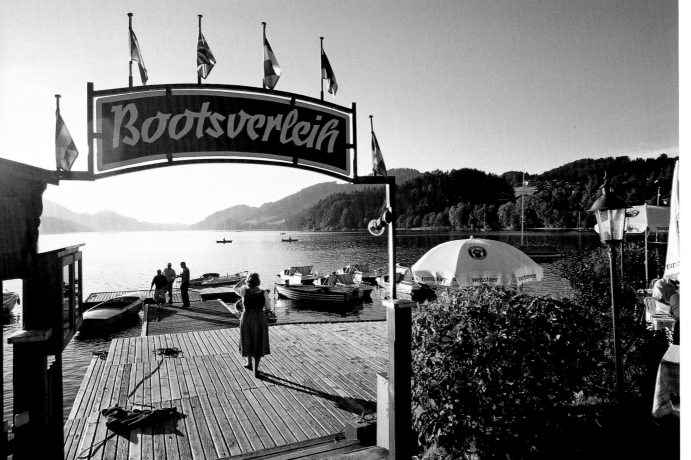

You can also mess about in boats on the romantic Fuschlsee. Fuschl is popular with romantics for another reason; the newly renovated Schlosshotel not only provides top-class accommodation but is also where the famous Sissi trilogy was filmed in the 1950s.

Page 46/47:
Mountain chalet Himmelspforte is not called "the gates of Heaven" for nothing! Clinging precariously to the summit of the Schafbergspitze high up above St Wolfgang, this is where at the beginning of the 19th century the royals of Vienna had themselves transported to in litters. A rack railway now eases the ascent.

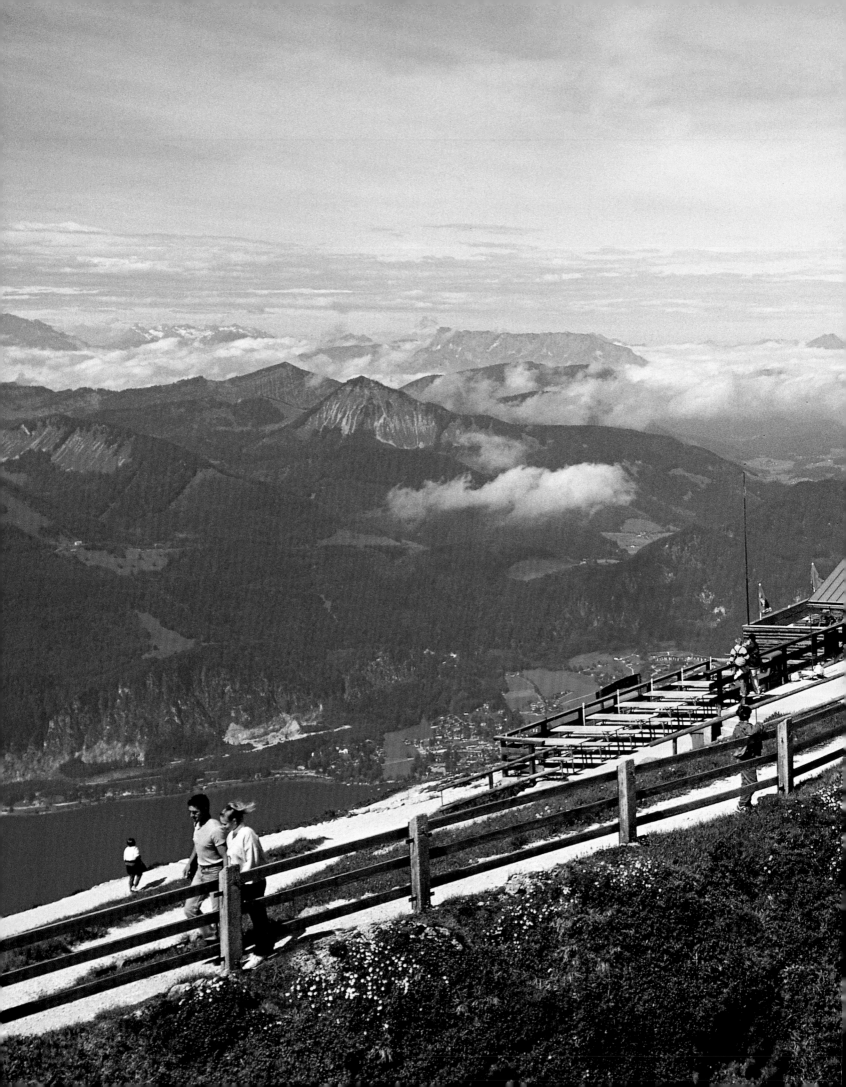

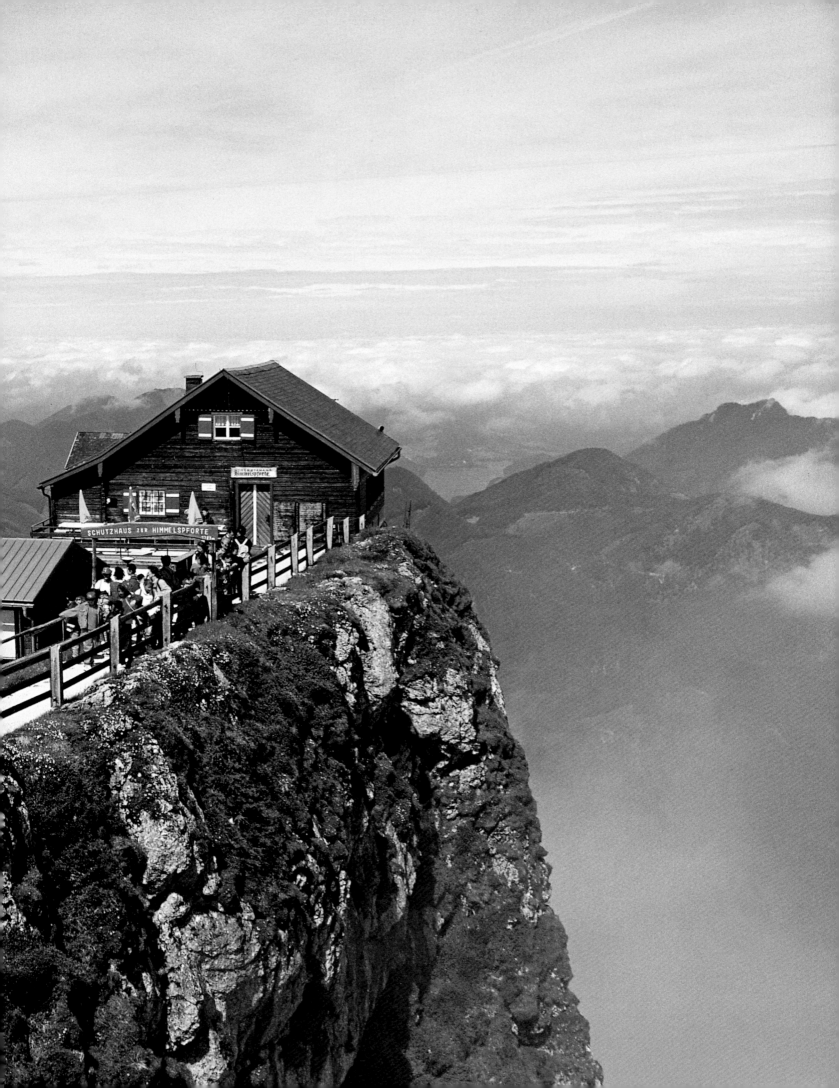

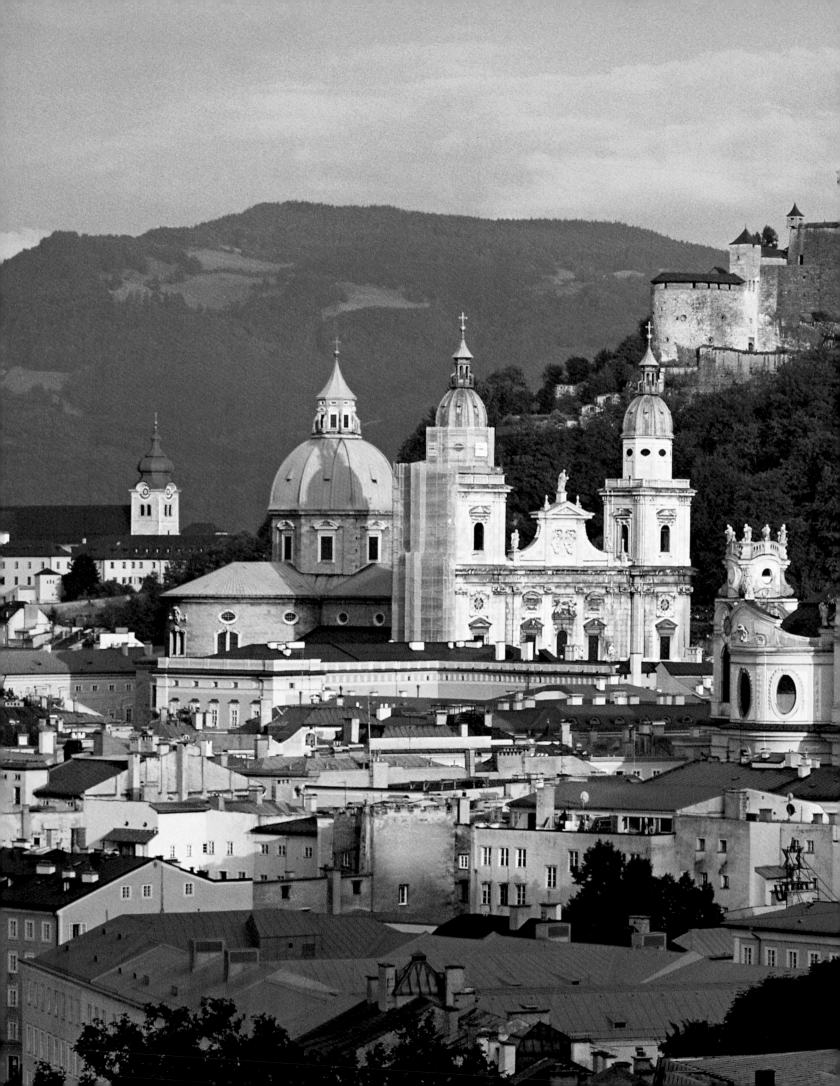

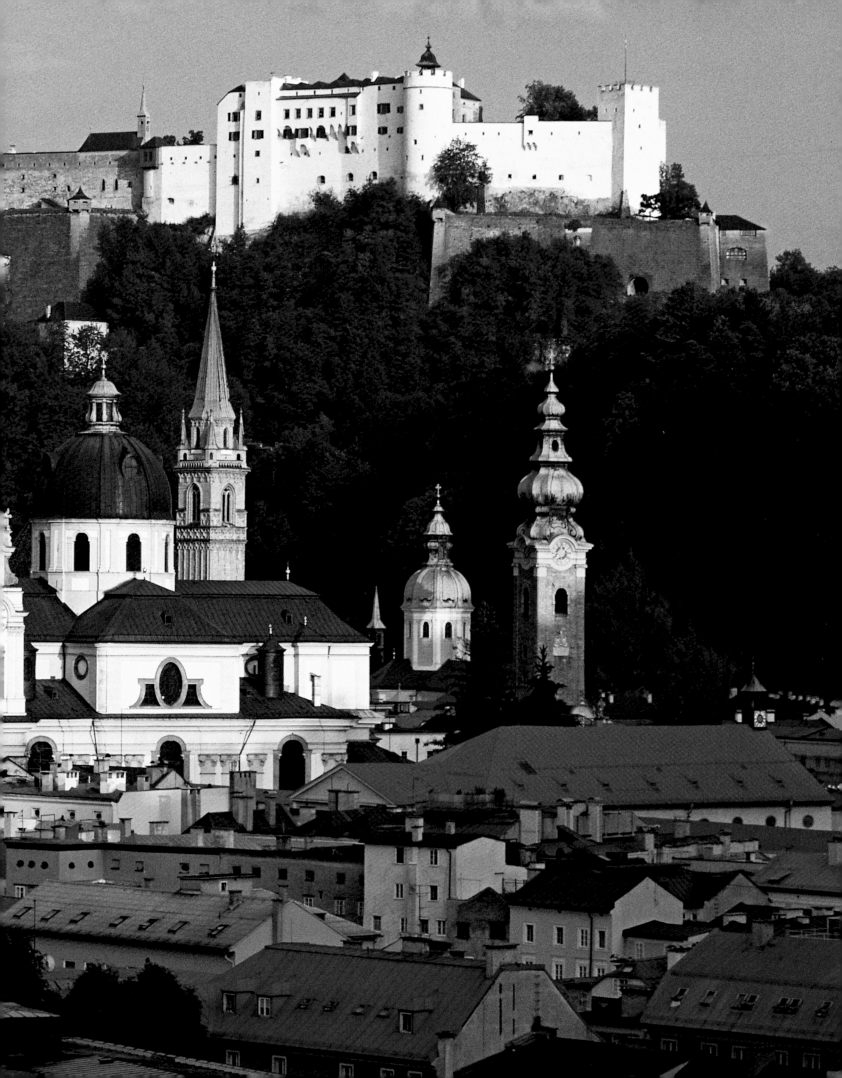

Page 48/49:
From the Humboldt-Terrasse on the Mönchsberg there are magnificent views of Old Salzburg and the fortress of Hohensalzburg. The city on the Salzach, with its domes and spires, is considered to be one of the most beautiful in Europe. It was made a UNESCO World Heritage Site in 1996.

Residenzplatz and Mozartplatz are where the heart of Salzburg beats the strongest. The old Café Glockenspiel to the right of the cathedral, residential palace and Michaelskirche has recently been taken over by the imperial and royal confectioner's Demel.

Mozart's place of birth on Getreidegasse is probably by far the most visited attraction in all Salzburg. The Mozarthaus on Makartplatz 8 is also well furnished with original exhibits.

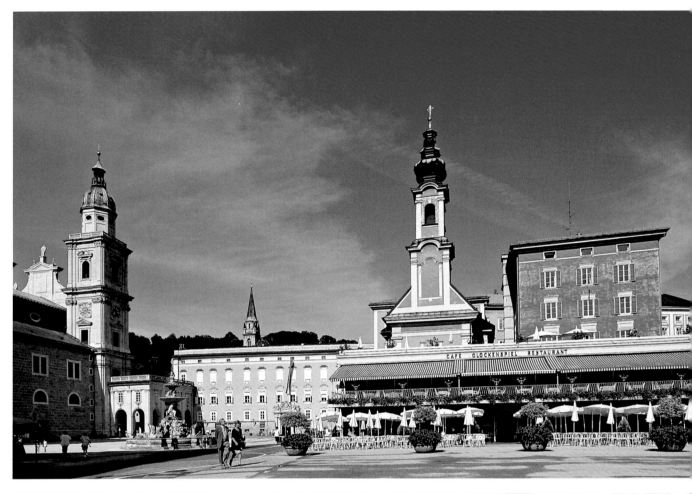

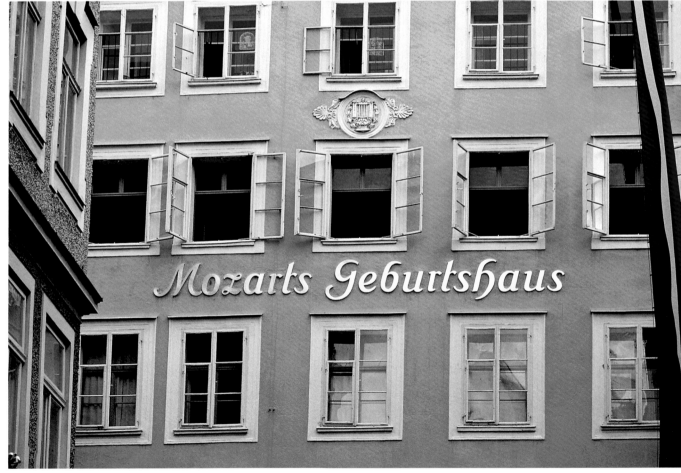

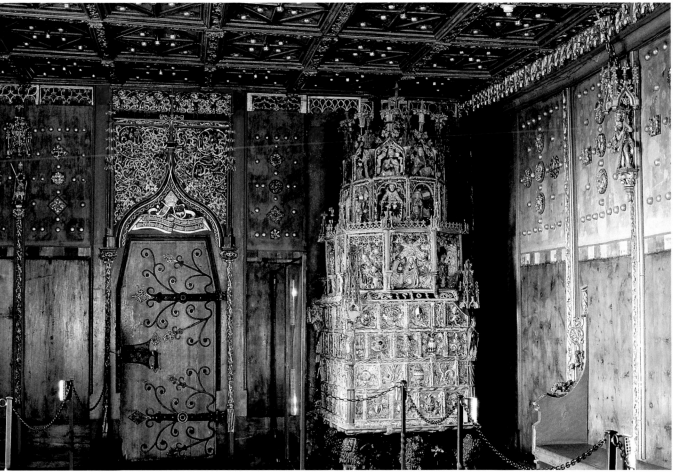

Festung Hohensalzburg
is the largest completely
preserved medieval fortress
in the whole of Europe.
One of its attractions is the
colourfully glazed Dutch
stove from 1501 in the
Goldene Stube or Golden
Chamber. The fortress also
has good views of the city
and environs.

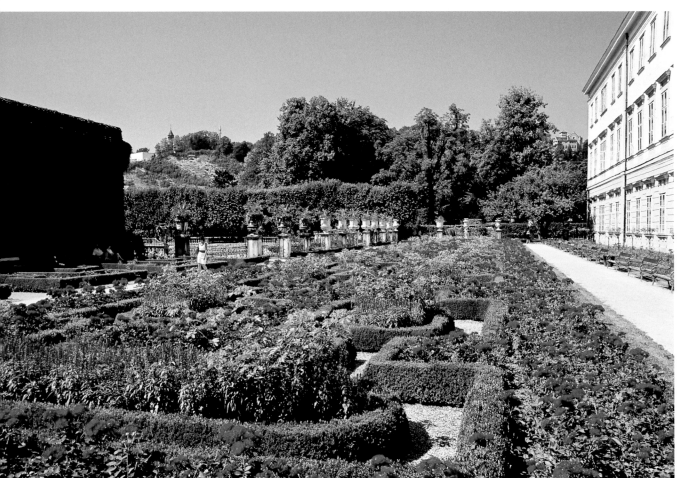

Yet more grand vistas are
promised by the Mirabell-
garten. Archbishop Wolf
Dietrich von Raitenau had
Schloss Mirabell erected
for his mistress Salome Alt
in 1606. One of its features
is the Zwerglgarten which
is full of stone dwarves
representing various char-
acters and professions.

51

With its conservatoire and two universities Graz, the capital of Styria and the second-largest city in Austria, is the cultural and economic centre of the region. The photo shows Schmiedgasse, one of the busy shopping streets in the middle of town.

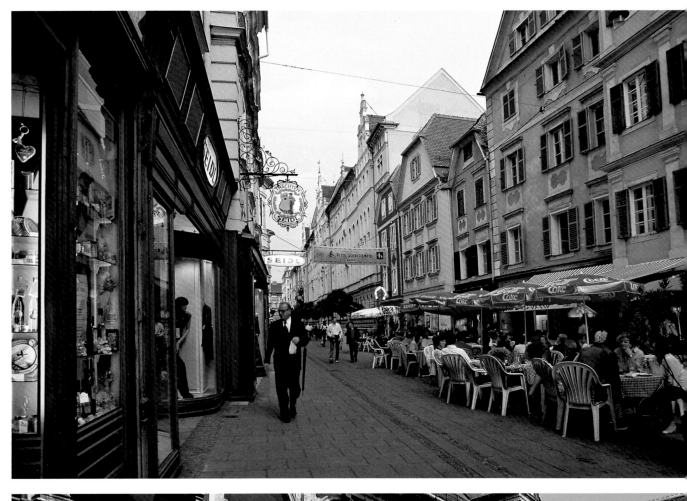

The Renaissance Landhaus in Graz is now the seat of Styria's provincial government. Built from 1557 to 1565 by Domenico dell'Allio, the courtyard has three-storey arcades running along two of its sides. Next door is the Landeszeughaus or armoury which houses a unique collection of weapons.

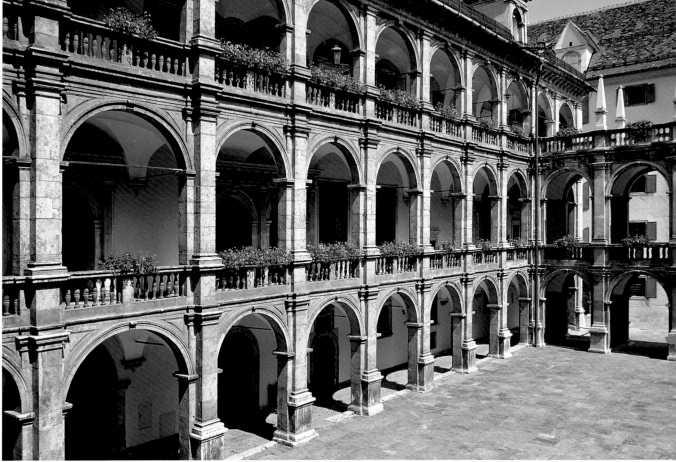

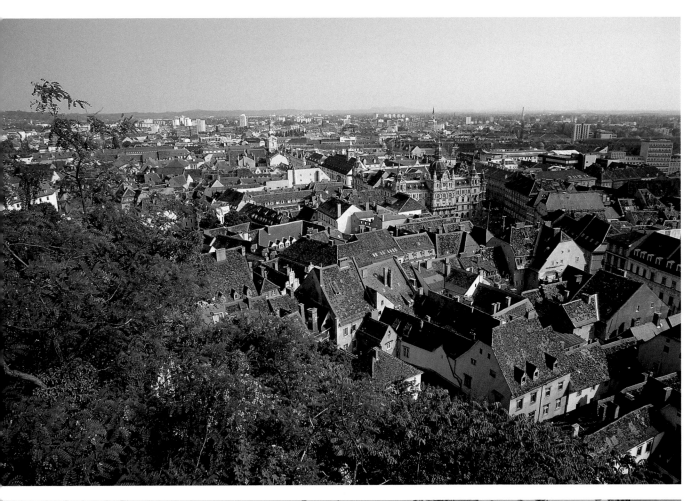

Looking down from the Schlossberg onto the jumble of roofs in Graz. The old town was made a UNESCO World Heritage Site in 1999. Since being named Cultural Capital of Europe in 2003 many new arts facilities have been installed, attracting visitors from all over the world.

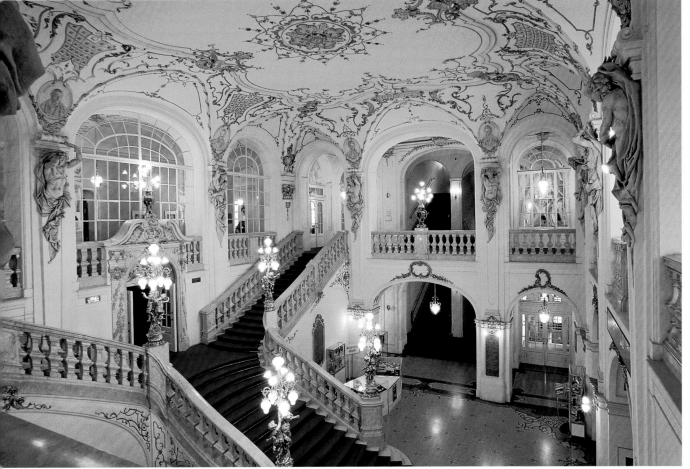

The opera house in Graz is considered to be one of the world's finest, built in 1899 in the style of baroque architect Johann Bernhard Fischer von Erlach, himself a native of the city. Other local heroes of renown active at the opera house include composer Robert Stolz and conductor Karl Böhm.

Page 54/55:
The region around Pürgg is both the cradle of Styria and the geographical centre of Austria. Not far from the village the mighty Grimming rises 2,351 metres (7,713 feet) up into the air, the easternmost foothill of the Dachstein Massif and one of the most imposing mountains in Styria.

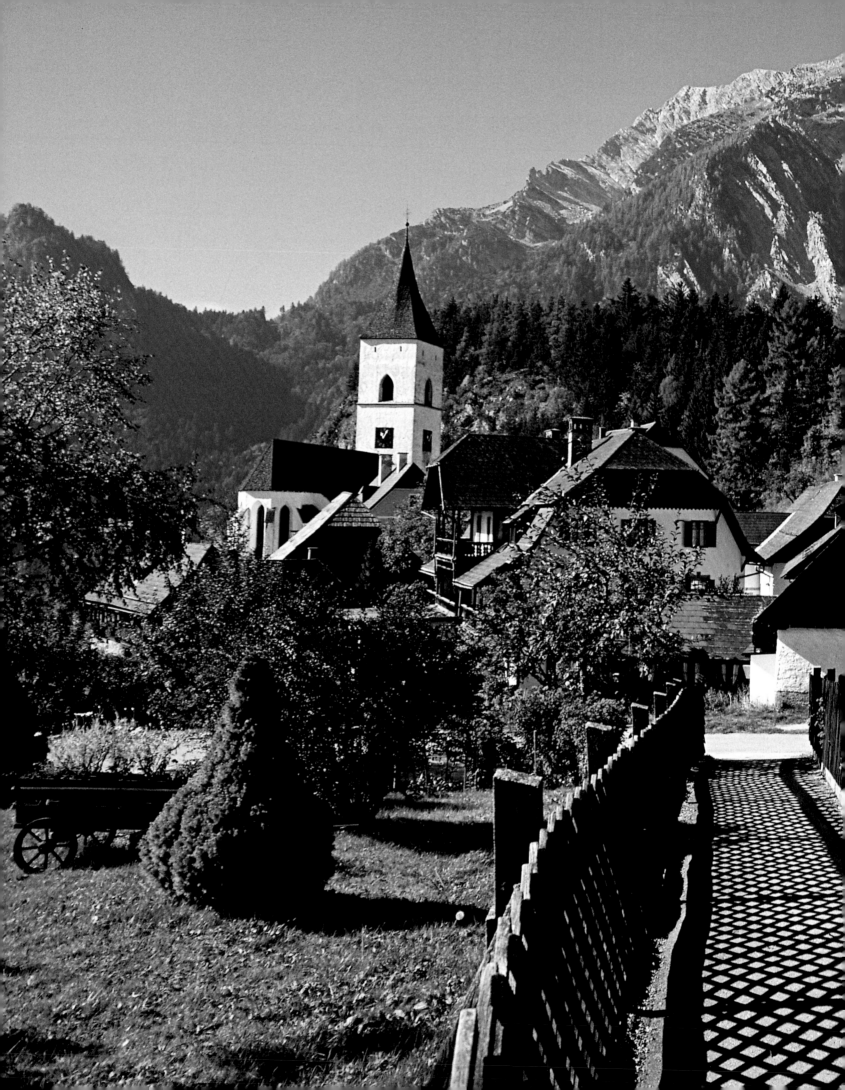

Dachstein Mountain straddles the provincial boundaries of Upper Austria, Salzburg and Styria. The area between the massif and the deep-cut valley of the River Enns is taken up by an enormous plateau, with the village of Ramsau spread out across it.

Much smaller than many of its Alpine counterparts, the Toplitzsee in the Ausseer Land can only be reached on foot. Shrouded in legend, it was long rumoured that treasure lay buried in its depths. Fiction became fact when in 1959 wooden chests containing counterfeit banknotes to the value of 500 million Austrian shillings were unearthed…

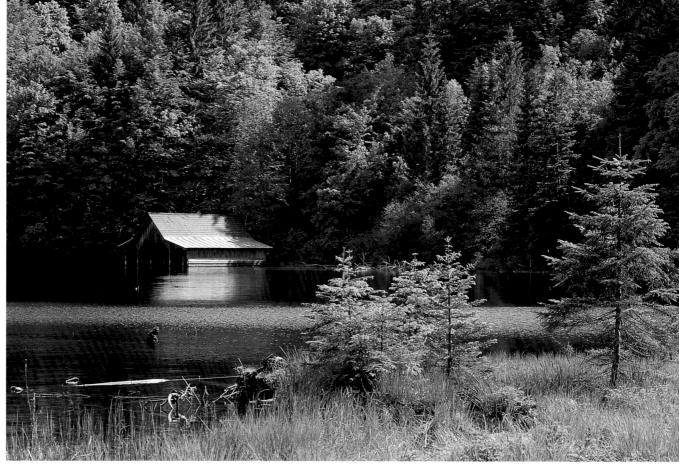

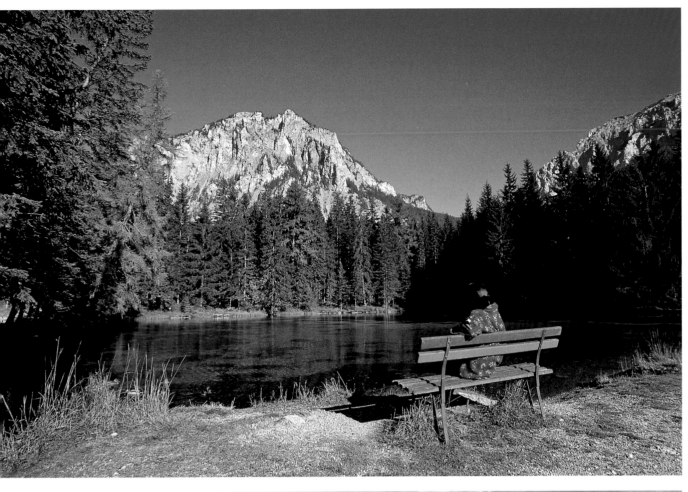

The Pfarrerteich is in the valley of the Tragöß in Styria at the foot of Hochschwab Mountain. Writer Peter Rosegger visited Tragöß many times, recounting the events surrounding the murder of Father Melchior Lang here in his novel "Der Gottsucher" (The God Seeker), first published in 1883.

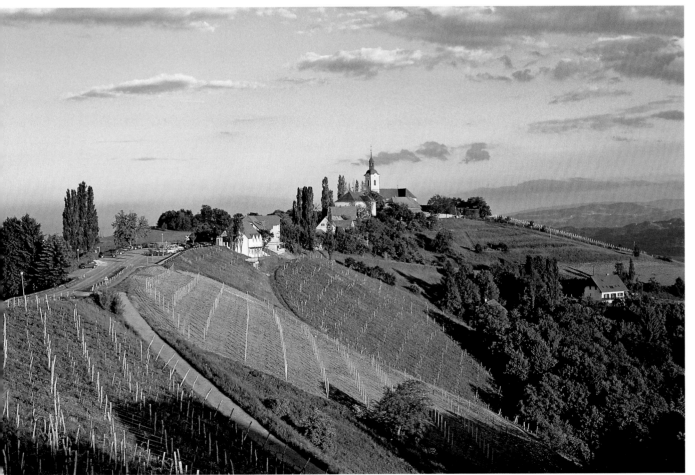

The highest-lying winegrowing village in Europe, Kitzeck im Sausal, has over 20 wine taverns where you can savour the local vintages. Birds are kept off the ripening grapes by the biggest scarecrow in the world, a type of windmill with eight sails which doubles as the area's local emblem.

Page 58/59:
The baroque library at the Benedictine abbey of Admont in Upper Styria is famous far and wide. Founded in 1074 the abbey burned down in 1865 – the library luckily survived – and subsequently had to be rebuilt. There are over 100,000 books in the stacks, including 1,100 manuscripts and 900 incunabula.

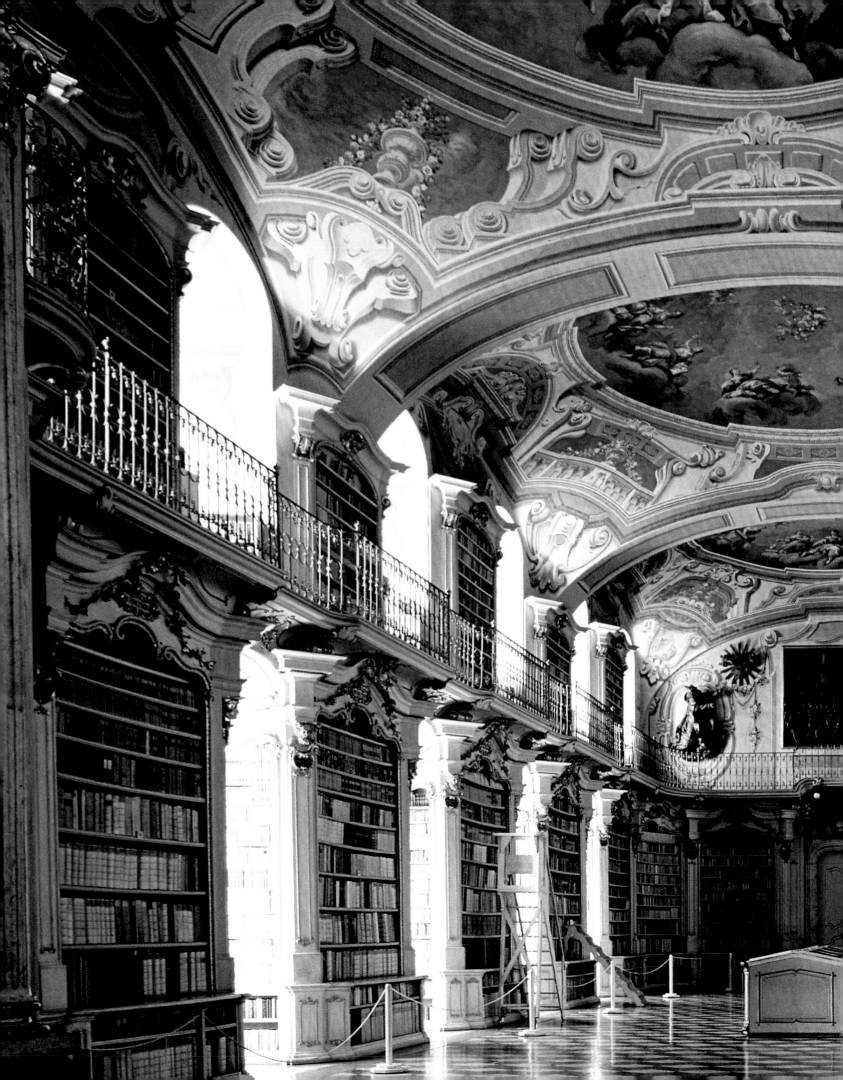

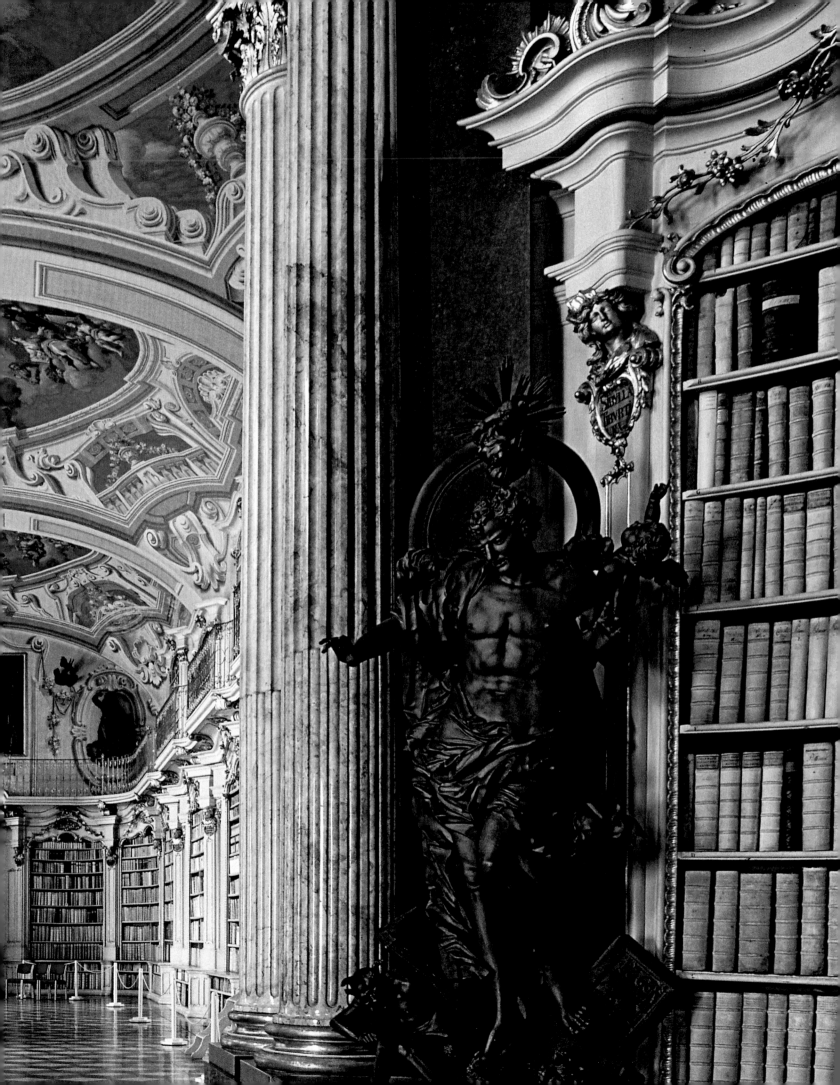

The Pöllatal conservation area in Carinthia is closed to traffic in the high season, with transportation between the villages provided by the local railway. The park has plenty of easy hiking trails; more challenging terrain can be found in the nearby Hafner Group.

Medieval Burg Groppenstein near Obervellach is claimed to be one of the best in Carinthia. The village also has a private collection of curiosities, whose exhibits include the shoes Reinhold Messner wore when he climbed Mount Everest. Schloss Trabuschgen and two other castles are also nearby.

Right page:
Heiligenblut at the foot of the Großglockner is the final stop on the Großglockner-Hochalpenstraße. The village, popular with visitors in both summer and winter, has a splendid 15th-century Gothic church which is well worth a visit.

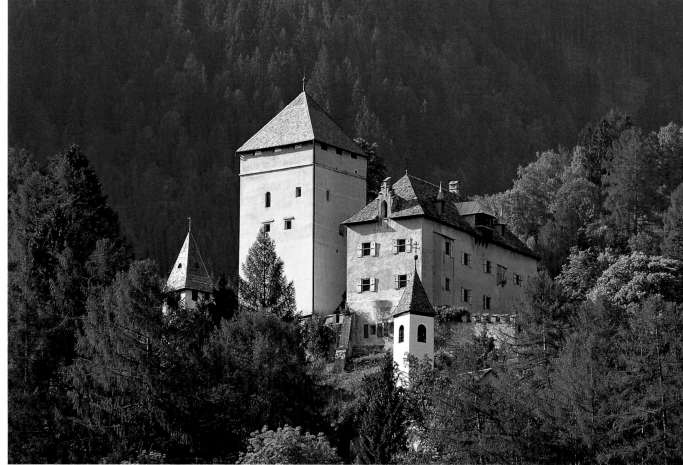

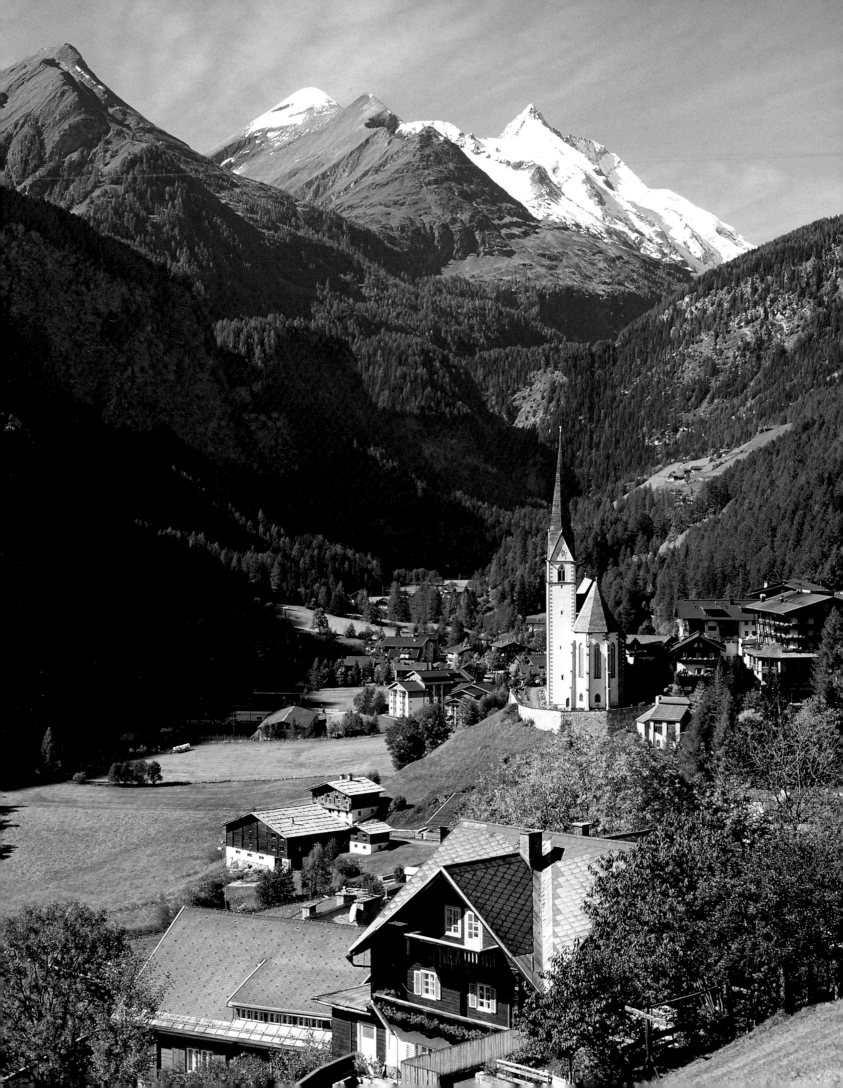

The best place to embark on a tour of Klagenfurt, the provincial capital of Carinthia, is the Altes Rathaus with its Renaissance portal. Alter Platz is also charming, where grandiose baroque facades are interspersed with the simpler edifices of the Biedermeier period.

Neuer Platz is dominated by the Lindwurm-Brunnen, a fountain erected in 1593. The legend goes that a great and terrible monster once inhabited the swamps outside Klagenfurt, slain by Hercules who enticed it from its lair with a fatted bull. The lindworm is now the heraldic emblem of Klagenfurt.

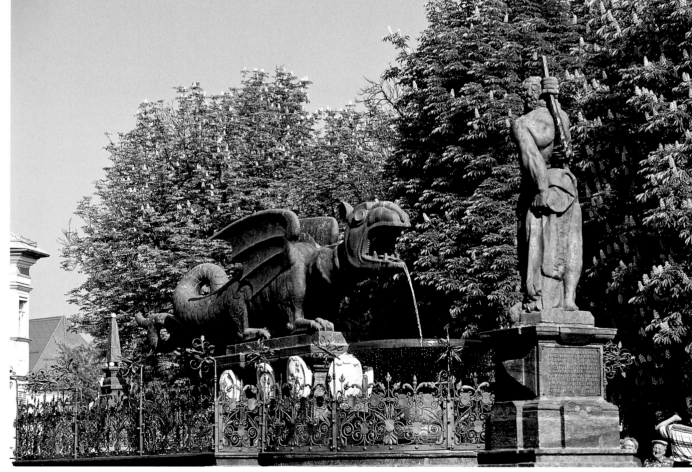

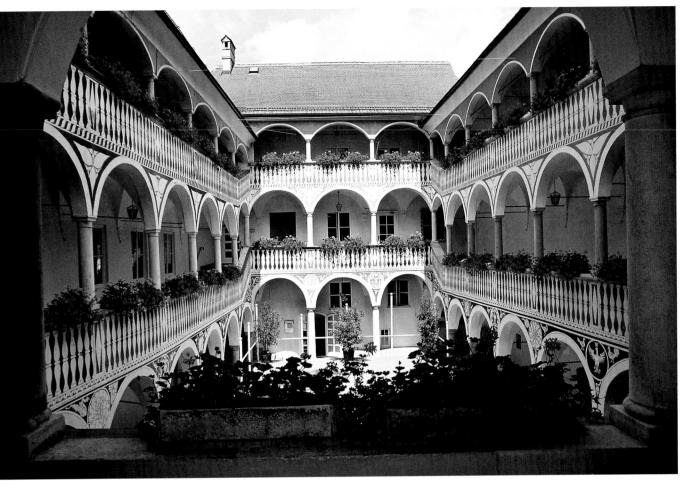

The town hall in St Veit an der Glan has had a turbulent architectural history. Originally late Gothic, the facade was later baroqueified and the inner courtyard decked out with Renaissance arcades and sgraffito frescoes. St Veit was the provincial capital of Carinthia from 1170 to 1518.

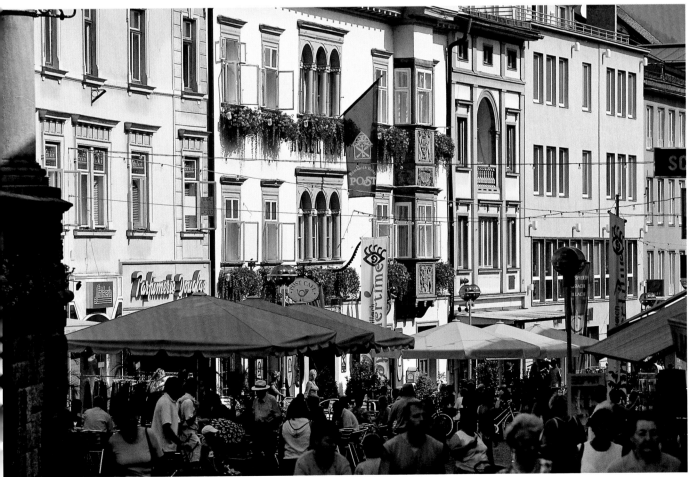

Villach, the "secret capital of Carinthia", is well sited on the River Drava and easily reachable from both Italy and Slovenia. The main square, surrounded by splendid patrician and town houses, has a good number of attractive shops, cafés and restaurants.

The Millstätter See, the most famous of Carinthia's many lakes, was first inhabited by Neolithic settlers. The town of the same name on its northern shores has been a spa for generations; its unspoilt southern reaches are perfect hiking country.

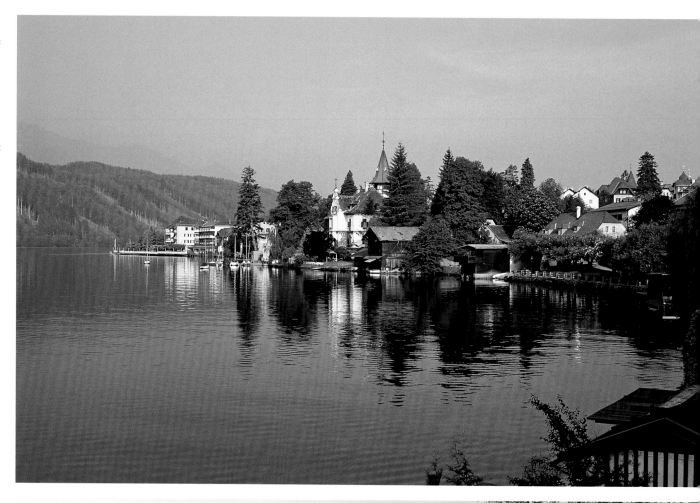

Southeast of Maria Wörth is the Keutschacher See. A road runs up from Keutschach to the Pyramidenkogel panoramic tower, from the top of which there are grand views out over the Wörther See and surrounding mountains.

Right page:
The late Gothic parish church of Maria Wörth is one of the landmarks of the Wörthersee. The Romanesque crypt, the late Gothic cloaked Madonna and the baroque interior are as fascinating as the round charnel house from 1278 in the cemetery. Very close by is the little winter or rosary church from the 12th century.

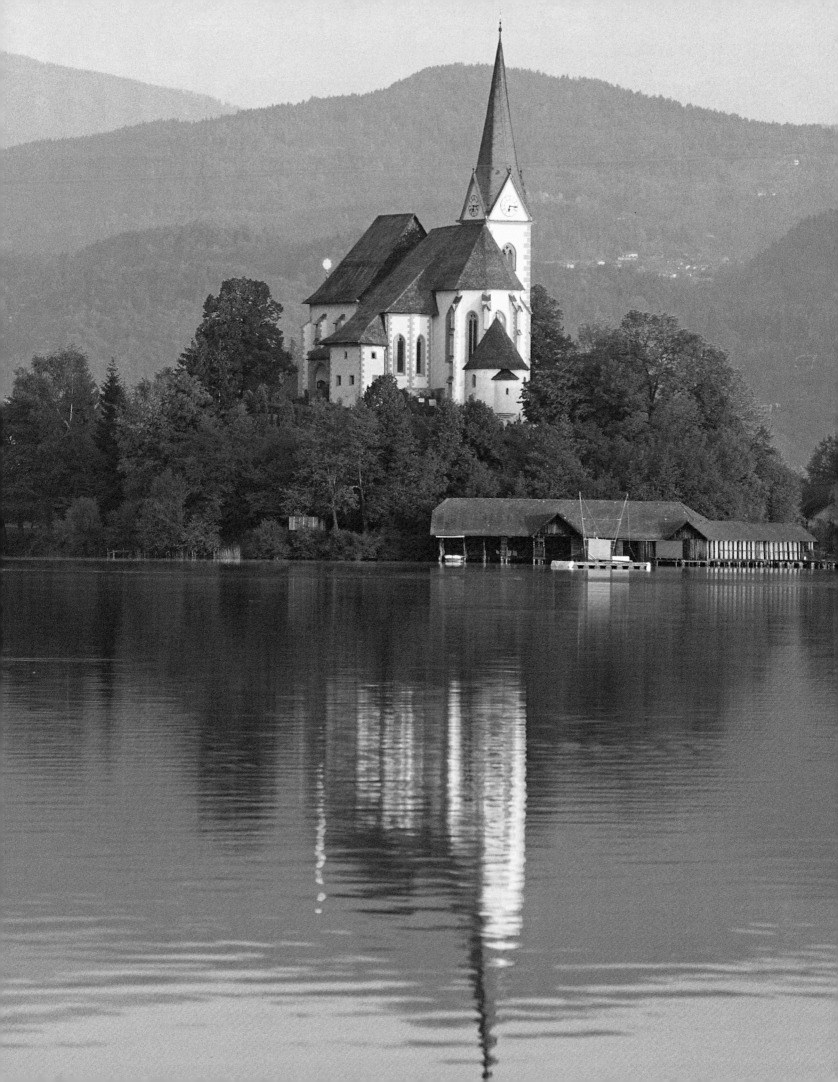

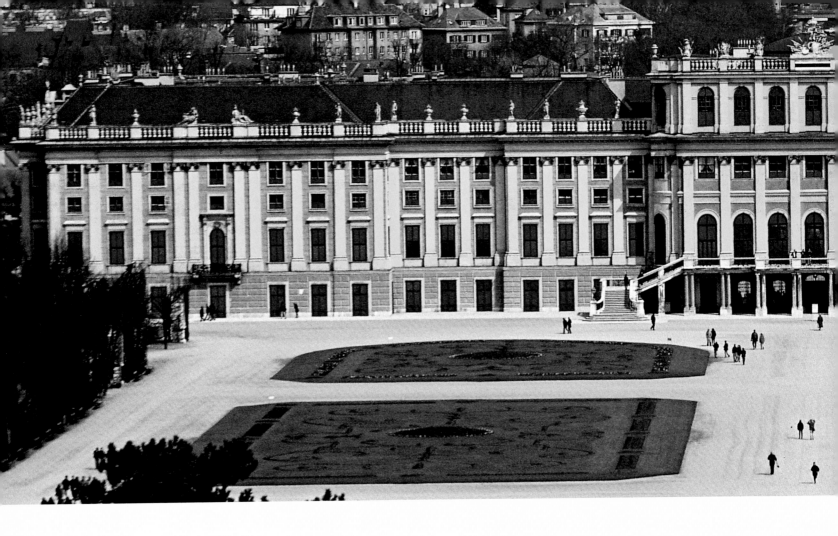

From Vienna to the Burgenland

In Vienna the latest stage in the adoration of Empress Sissi – the musical *Elisabeth* – has just begun its march of triumph across the globe. Vienna isn't just famous for its imperial palaces of Schönbrunn, Laxenburg and Hofburg, however. The oldest zoo in the world, the Spanish Riding School, the Prater funfair and the delicious *Sachertorte* are also big hits with visitors. From the noble Ringstraße to glorious aristocratic residences, from the Gothic cathedral to the vault of the Capuchins to the city cemetery: the list of unique attractions is endless. In a more relaxed vein there are *Fiaker* or horse-drawn carriages waiting to take you for a leisurely ride – and many different types of coffee to try at a *Kaffeehaus*. Revived, you could then take in a performance at the state opera house or the Burgtheater – or, if you're extremely lucky, twirl round the room at the famous Opernball. The latter definitely calls for ball gowns and tails – if you don't want to feel like Cinderella before the arrival of the Fairy Godmother…

One of the stars of Classical music in Vienna, Haydn, came from Rohrau on the border to the Burgenland. In the same vein as *God Save the King* he composed *Gott erhalte Franz den Kaiser* for the then rulers of Austria, the Habsburgs. Hoffmann von Fallersleben later rewrote the words to the Austrian melody to produce what is still Germany's national anthem. For many years Haydn lived near the Neusiedler See which – like so many other places in Austria – is the perfect spot to spend a (family) holiday.

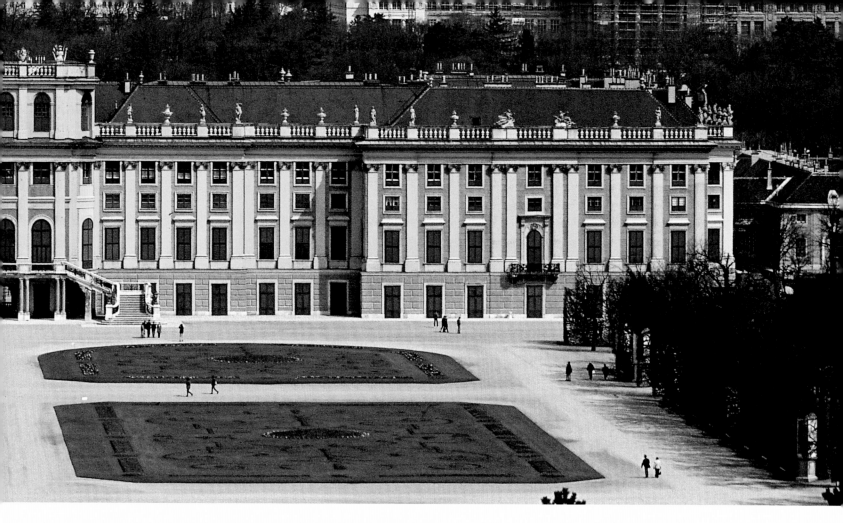

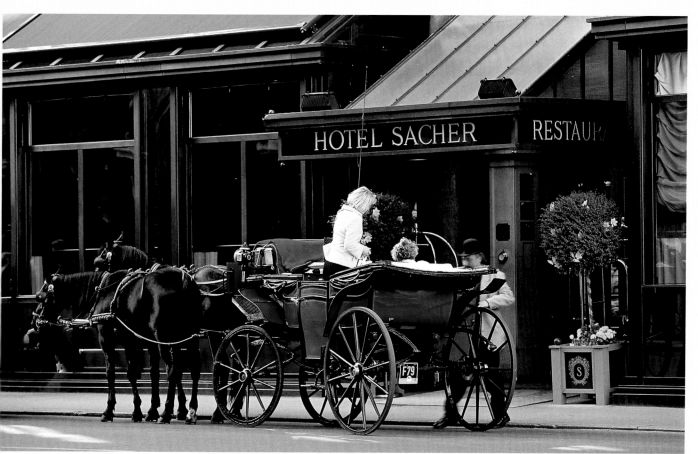

Above:
From the highest point in the grounds of Schloss Schönbrunn, the Gloriette pavilion, there are marvellous views of the famous palace southwest of Vienna. Mozart gave his first concerts here and Beethoven worked on "Fidelio" amongst the formal French designs of the palace gardens.

Left:
The world-famous Hotel Sacher is one of the main stops on a tour of Vienna in a Fiaker or horse-drawn carriage. The word "Fiaker" refers both to the hackney cab and to the cab driver with his bowler hat. It is derived from the Rue Saint-Fiacre in Paris where the main stand for carriages such as these was originally situated.

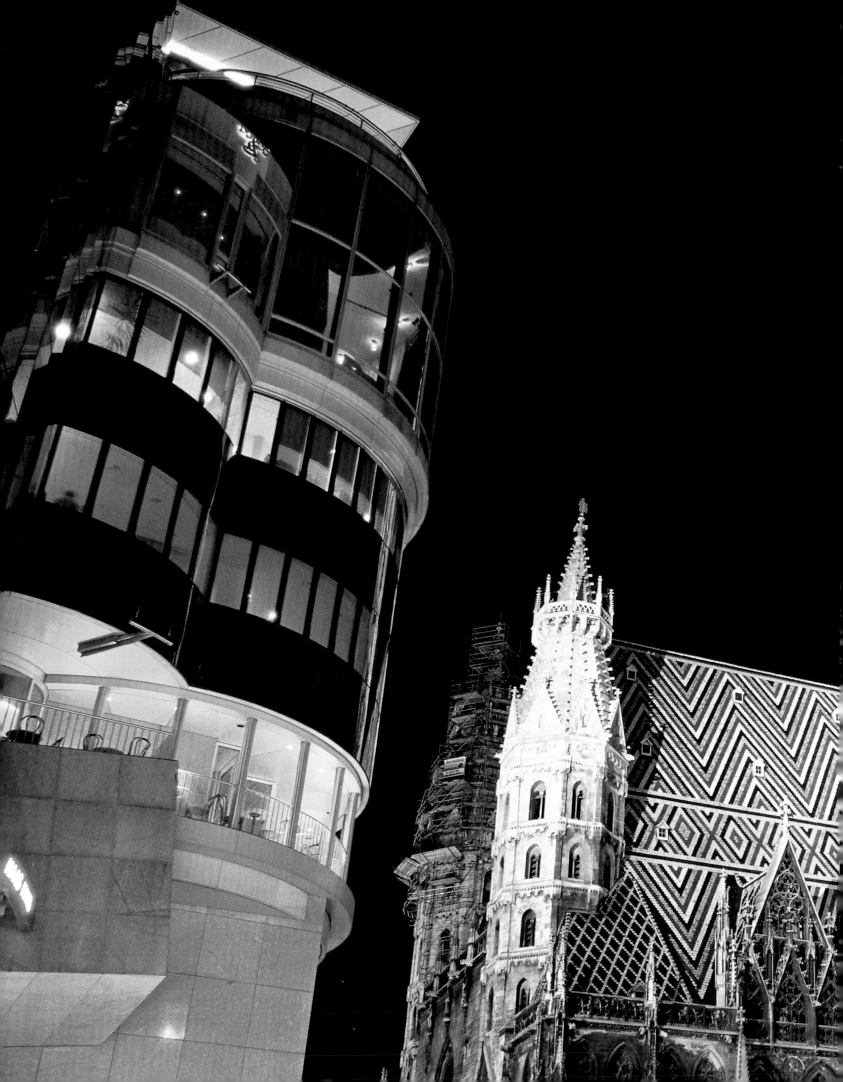

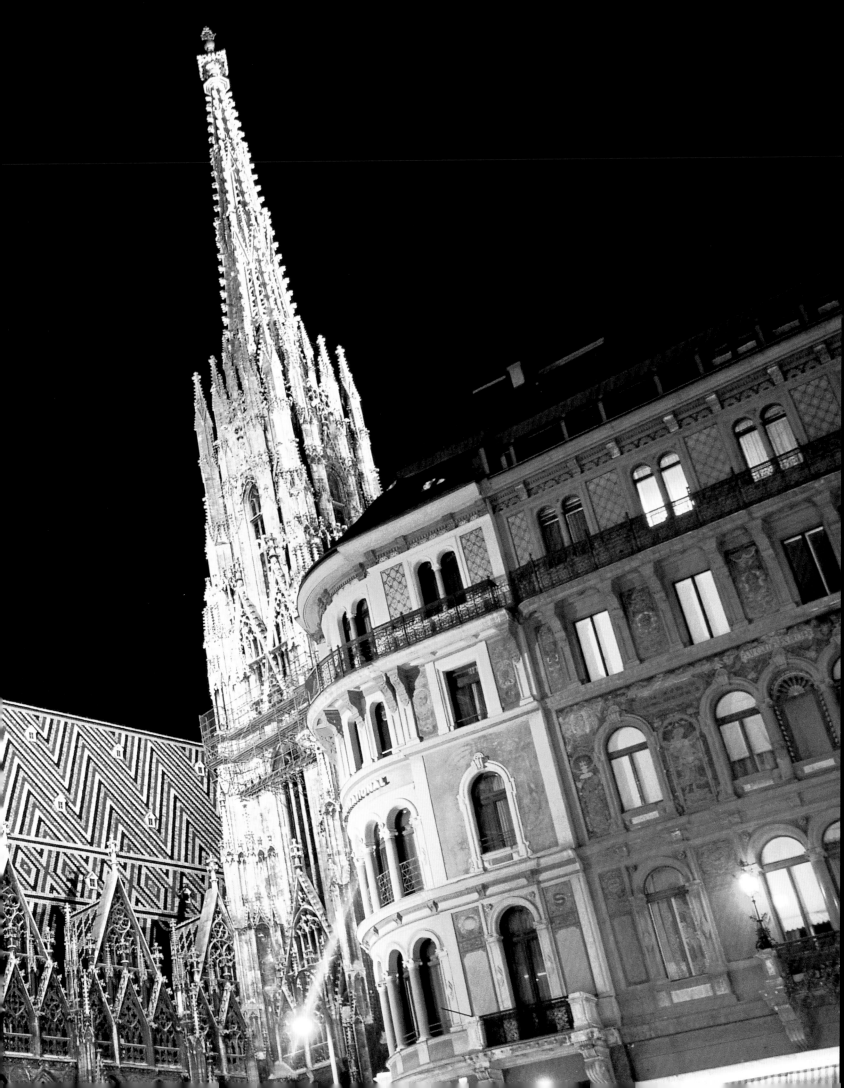

Page 68/69:
One of Vienna's chief landmarks is its cathedral, Austria's number one Gothic building. Stephansplatz which encircles the cathedral is also a popular place for an evening stroll. Hidden 12 metres (40 feet) underground is the Virgilkapelle, a chapel from the 13th century which, like the Stephansdom itself, is open to the public.

The eloquent feature writer Alfred Polgar was a regular at Café Central on Herrengasse in Vienna. His fitting literary portraits of many of his contemporaries, who came to the café "to be alone in company", make good reading even today.

Coffee is cult in Vienna. Café Gloriette is a good place to take in the view of Schloss Schönbrunn while enjoying a "Kleiner Brauner" (small cup of coffee with a little milk), for example, or an "Einspänner" (double mocha in a glass mug with cream). Just make sure you don't simply order "a coffee"; you may not get served…

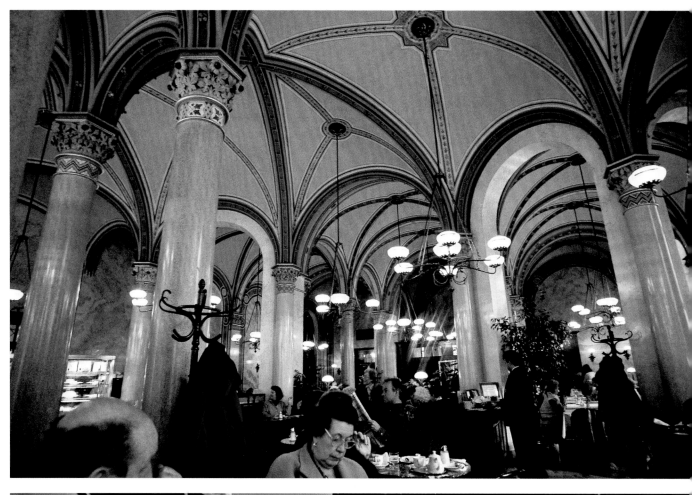

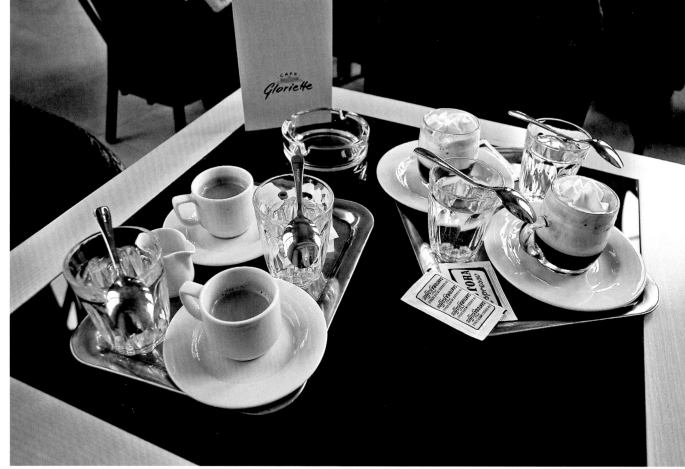

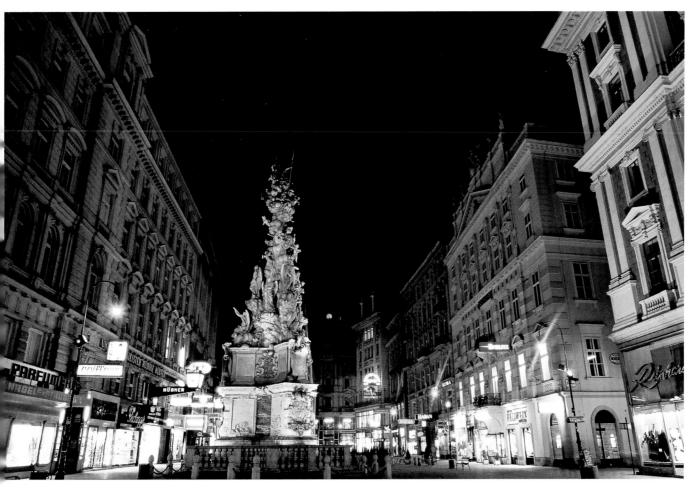

In 1679 Emperor Leopold I swore to erect a column reaching to the skies when the terrible pestilence ceased to plague Vienna. The result was the Pestsäule on Graben to which Johann Bernhard Fischer von Erlach, the architect of Schloss Schönbrunn, contributed.

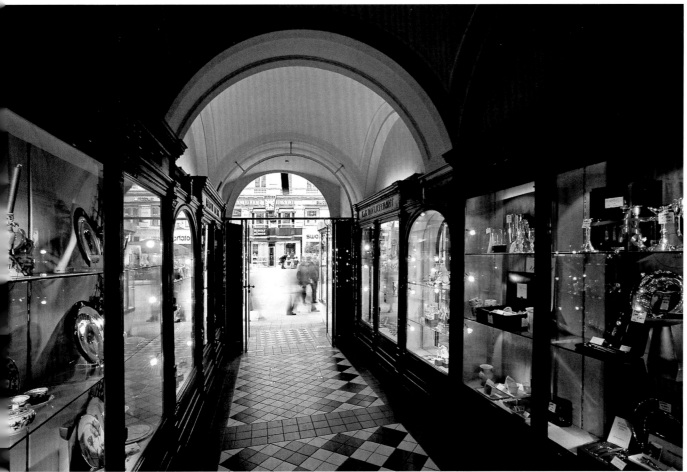

Once part of the Roman defences, Graben (literally: "ditch") is today one of the top shopping boulevards in the Austrian capital. This 19th-century arcade cutting off from the main drag has recently been restored and has lots of tempting goodies on display in its expertly dressed windows.

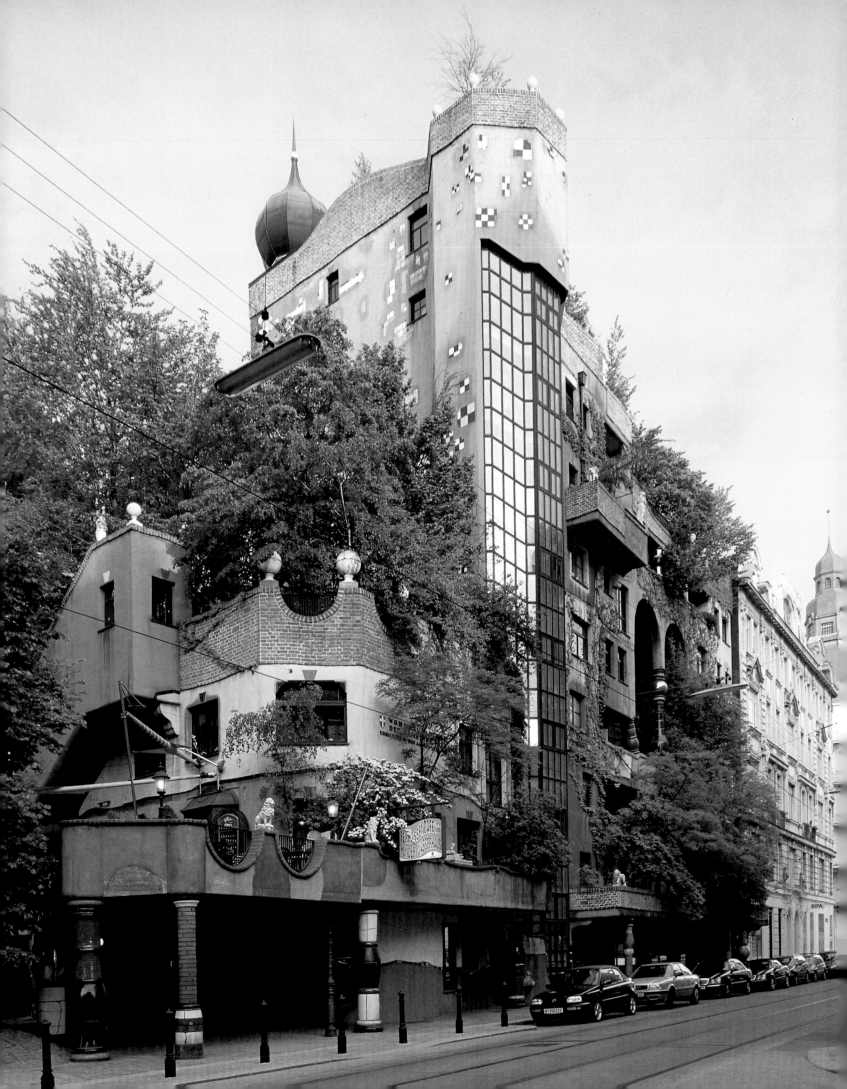

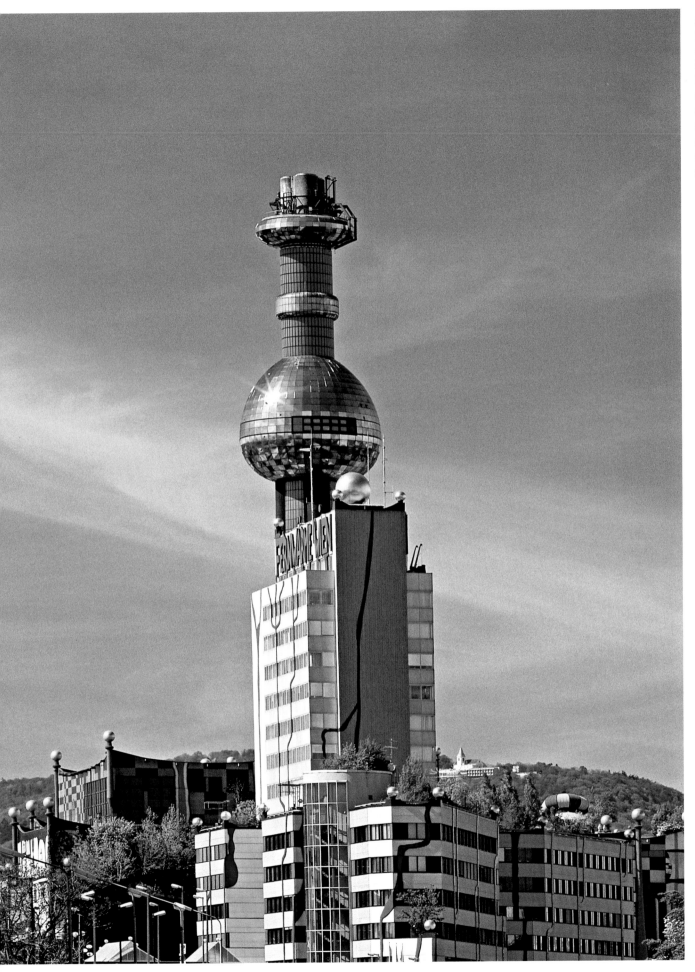

Left page:
Friedensreich Hundert-
wasser's residential and
business complex on
Löwengasse isn't just
colourful; he also set great
store by the use of natural
materials such as bricks
and wood. A number of
artists and intellectuals
now live here.

Left:
Despite looking like some-
thing out of "Arabian
Nights" the refuse site in
Spittelau, also planned
by Hundertwasser, has a
strong ecological bent.
Waste heat generated by
the plant is used to warm
many households in Vienna.
The fantastical complex
also offers guided tours.

Vienna's Prater is a funfair with tradition, with the first stalls opening for business here in 1767. No trip to the city would be complete without a go on the enormous Ferris wheel, itself something of a traditional Viennese institution.

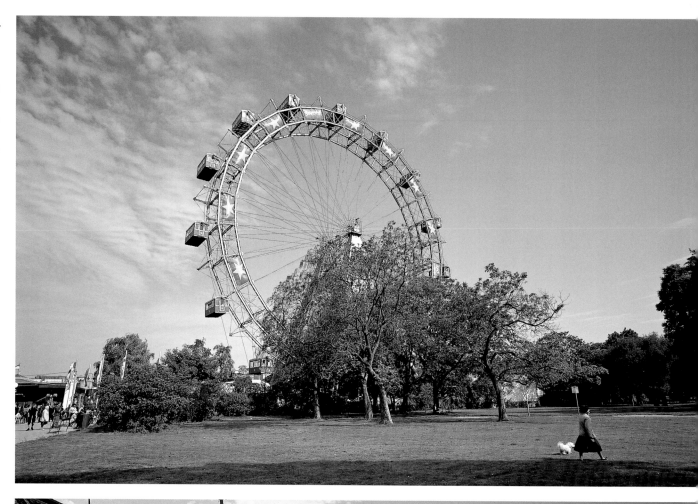

The Pummerin bell, one of the biggest in town, is easily reached by lift which smoothly ascends the north tower of the cathedral. The bell is only rung on special occasions and high feast days. From the tower there are impressive views out across the metropolis towards the northwest.

Right page:
The man responsible for much of modern Vienna, Emperor Karl VI, had Fischer von Erlach build him the Karlskirche. Austria's most famous baroque architect duly created a synthesis of Mediterranean extravagance and Viennese gracefulness. The church is dedicated to the patron saint of the plague, St Charles Borromeo.

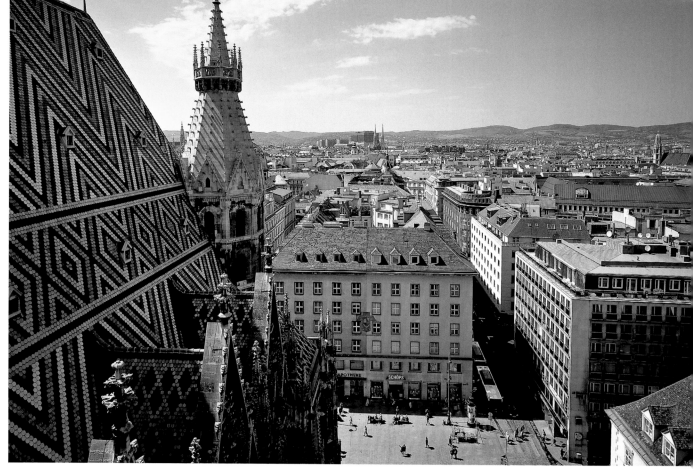

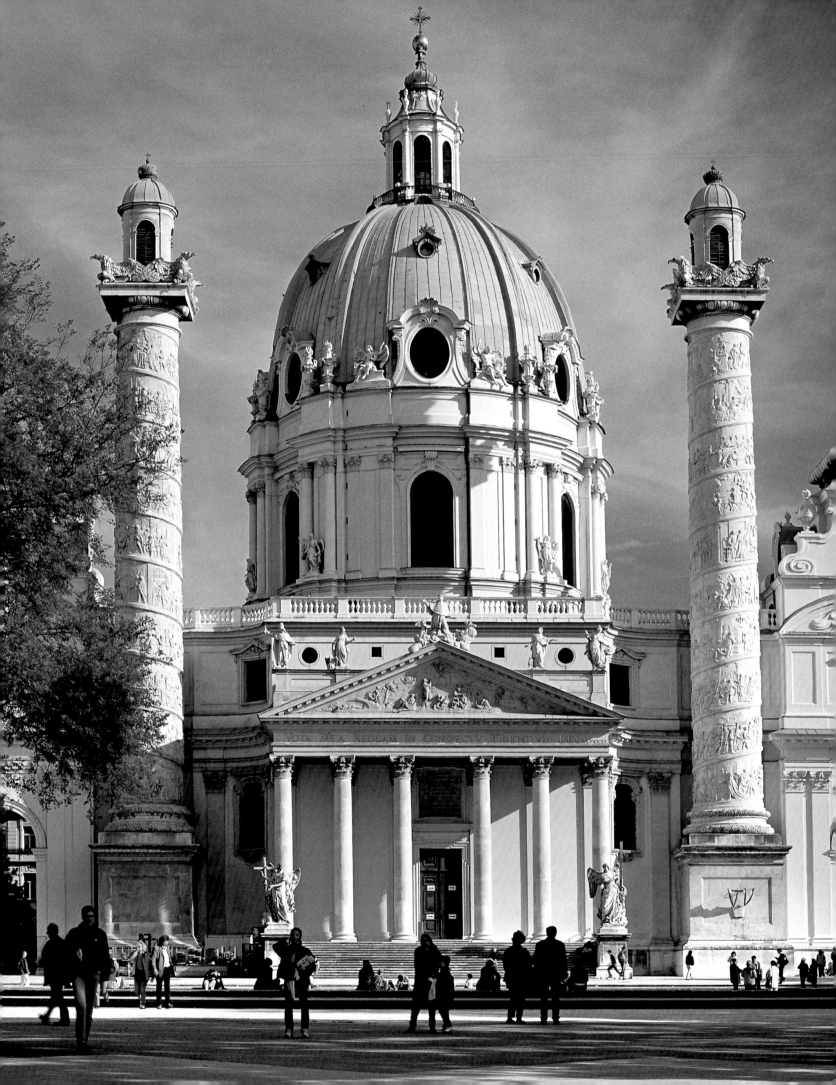

A Pragmatic Sanction permitted Maria Theresa, the daughter of Karl VI, to ascend to the imperial throne. Her monument stands outside the Kunsthistorisches Museum which houses one of the most significant art collections in the world.

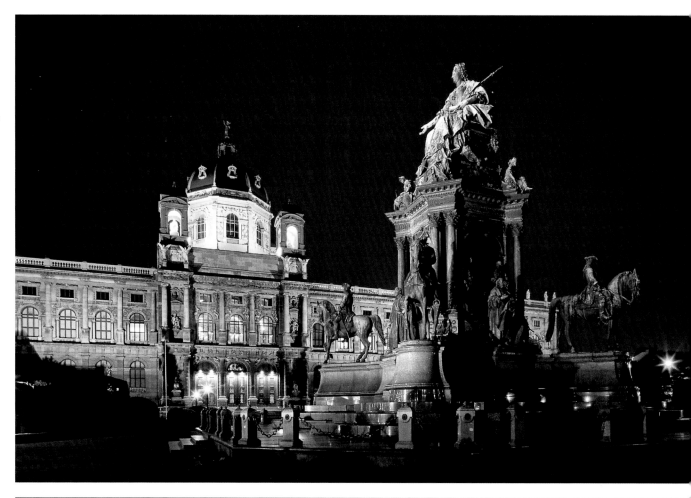

In allusion to the birthplace of democracy, Greece, between 1873 and 1883 Theophil Hansen built the parliamentary building for the new House of Representatives of the Dual Monarchy of Austria-Hungary, founded in 1861. Today sessions of the National Assembly and Upper House are held here.

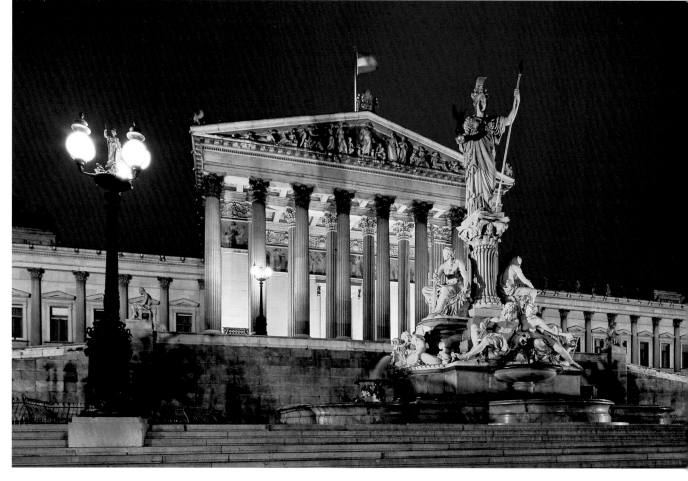

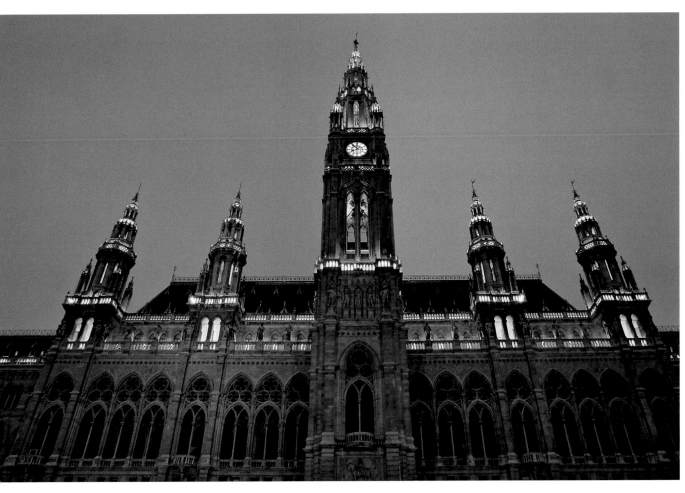

As befits its status as capital of Austria the city hall in Vienna is suitably enormous, taking up much of the old parade ground. This is where the local council and also the provincial government meet, as Vienna is both a city and a province in its own right.

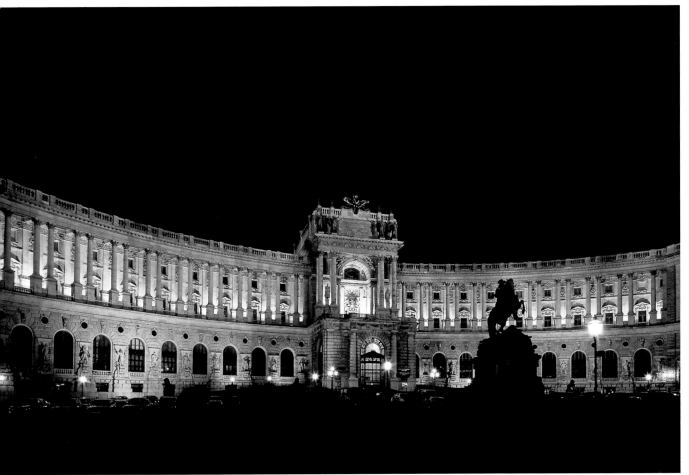

The complex of the Hofburg or imperial palace on Heldenplatz in Vienna is no less extensive in its proportions. Austria's president now lives and works in rooms once inhabited by Maria Theresa and Joseph II. The Neue Burg, whose interior wasn't fully completed until 1926, also looks splendid at night.

Page 78/79:
Dürnstein, the "pearl of the Wachau", is enclosed by walls which creep up to the mighty ruin high above the town. It was here in 1193 that English King Richard the Lionheart was held prisoner by Duke Leopold VI of Austria whom he had offended during the Crusades.

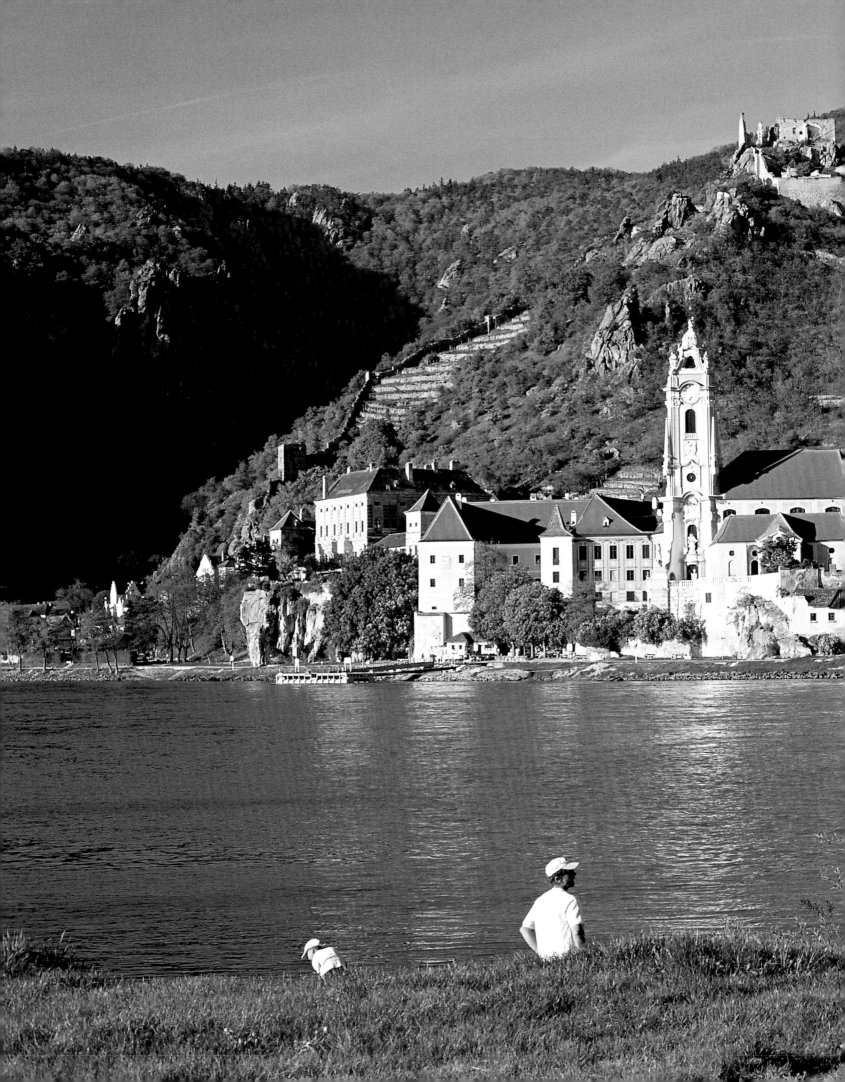

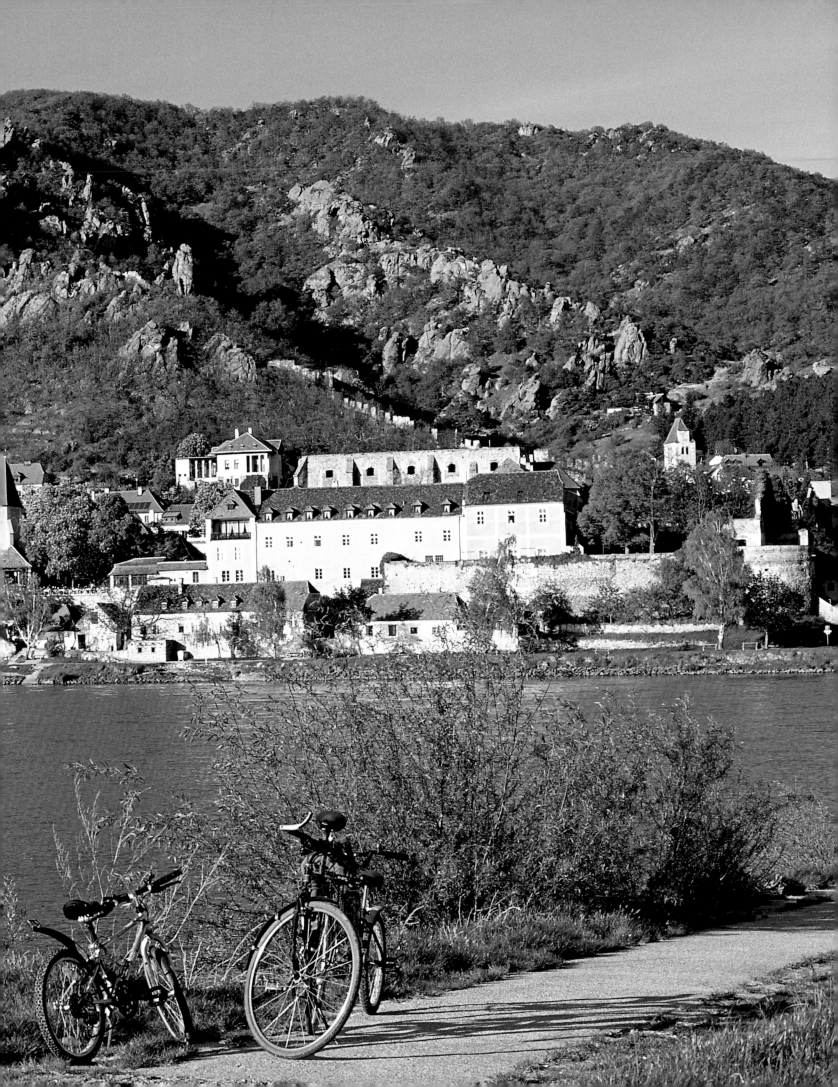

The Benedictine abbey of Melk in the Wachau is probably one of the best known and most magnificent monasteries in Austria. The buildings are grouped around no less than seven courtyards. The impressive west end of the huge complex is visible for miles around.

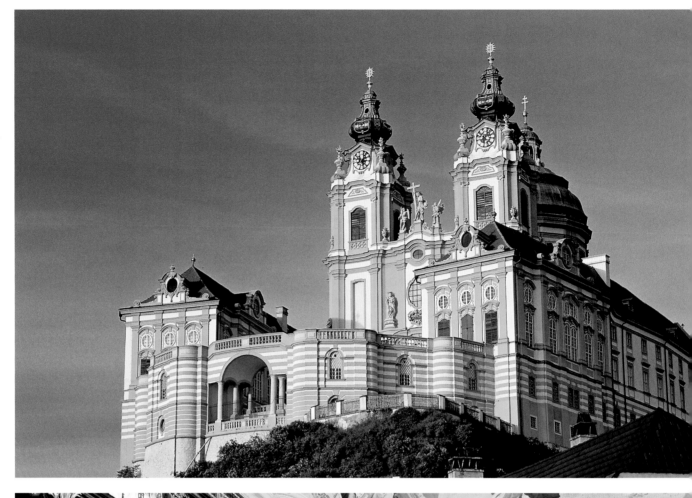

At the northern end of the Kolomanihof is the monastic library. The courtyard is named after St Koloman whose mortal remains were brought here in 1014. The library has a staggering 90,000 volumes, including 2,000 manuscripts and 850 incunabula.

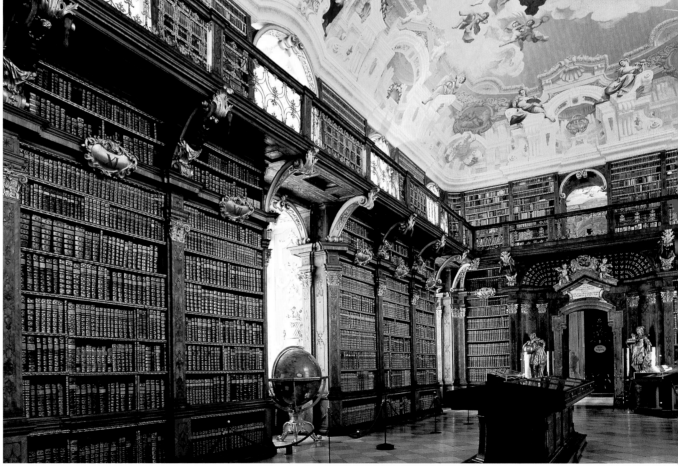

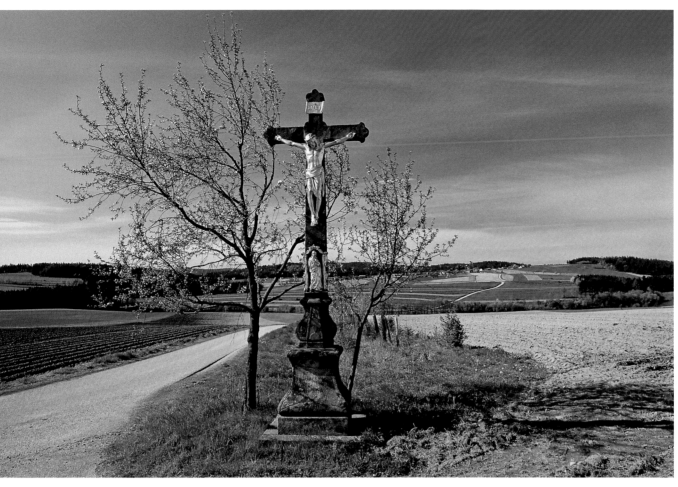

Off the beaten track there are plenty of idyllic spots to discover in Lower Austria's Waldviertel. Numerous castles, palaces and monasteries bear witness to a turbulent past and religious symbols, such as this wayside crucifix near Münchreith an der Taya, are manifestations of the strong faith harboured by the local populace.

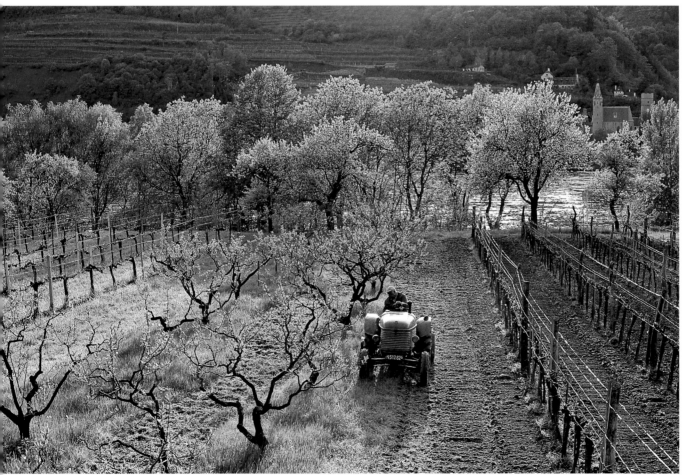

Apples and pears thrive as well as grapes here in the mild climate of the Wachau. Near St Johann im Mauerthale the plantations run right down to the banks of the Danube. The area is quite spectacular in spring when the trees are in blossom and in the autumn when the leaves have turned.

Austria's largest province, Lower Austria, curls around Vienna and for decades was without a provincial capital of its own. In 1986 St Pölten was chosen as the new administrative centre; since then it has seen much building activity to accommodate new offices and arts facilities. The photo shows Rathausplatz.

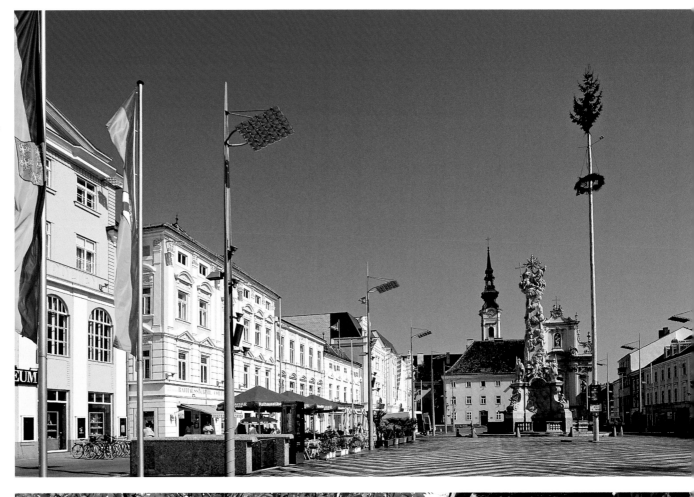

Baden near Vienna on the edge of the Vienna Woods is Austria's number one sulphur spa. Regular visits from the Viennese court secured its fame and fortune. You can soak up the atmosphere of the place and try some regional cuisine here at the nostalgic Café Damals.

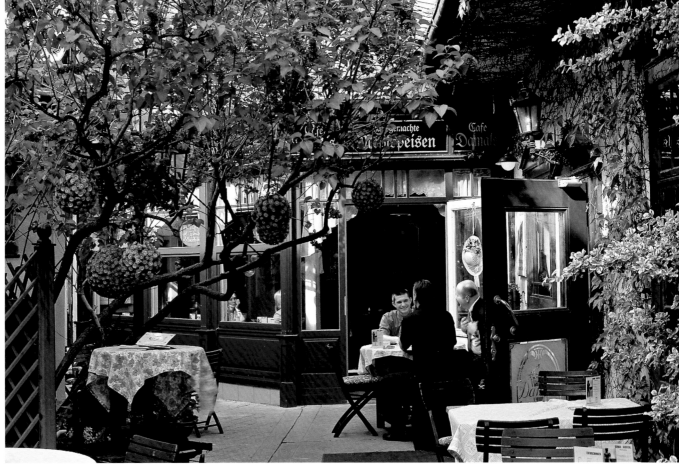

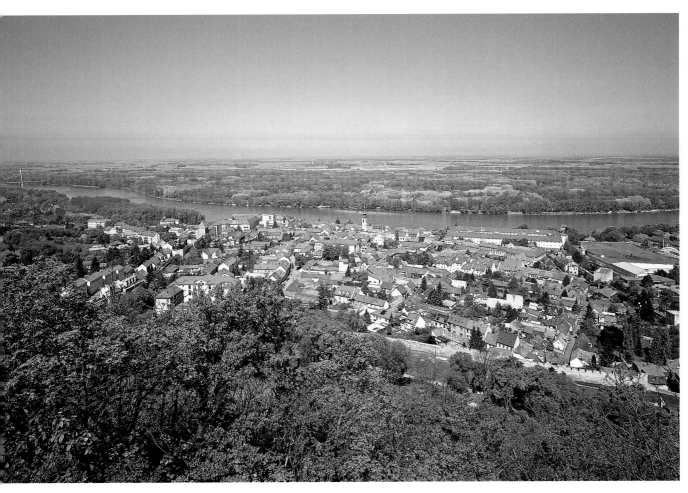

Hainburg on the Danube was once an important fortress defending the eastern borders of the Kingdom of Germany in the Holy Roman Empire. From the ruined castle on Schlossberg there are extensive views of the town below with its ancient defences, still in a good state of repair.

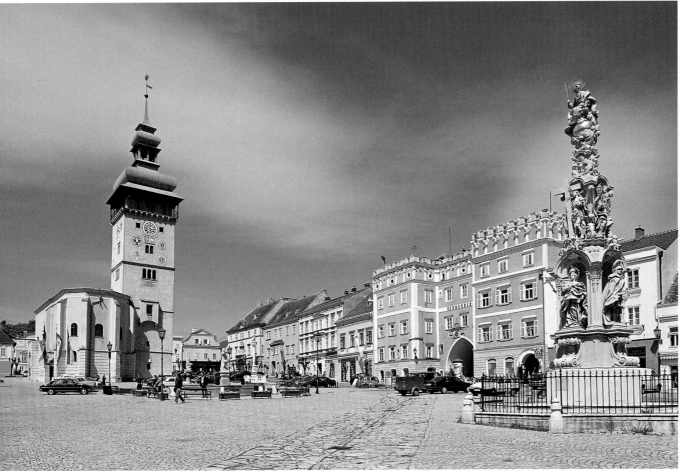

With the fall of the Iron Curtain trading across the border near Retz in the Weinviertel could again begin. The town's main square is dominated by the Rathaus from the 16th century and a richly decorated column dedicated to the Holy Trinity.

Page 84/85:
These long side alleys are typical of Mörbisch, a little village on the Neusiedler See in the Burgenland not far from the Hungarian border. The village is surrounded by vineyards and joined to the lake and beach by a long dam.

Heiligenbrunn with its unique streets of cellars hugs a slope near the Pannonian Plain in the southern Burgenland. Its uneven thatched roofs are a European rarity, decked with the ears of straw pointing to the outside. The village also makes wine from ancient varieties of grape.

Between the Neusiedler See and the Hungarian border lies the Seewinkel, a salt steppe full of ponds. A leisurely way of exploring this area with its rich diversity of flora and fauna is to take a ride on a horse and cart.

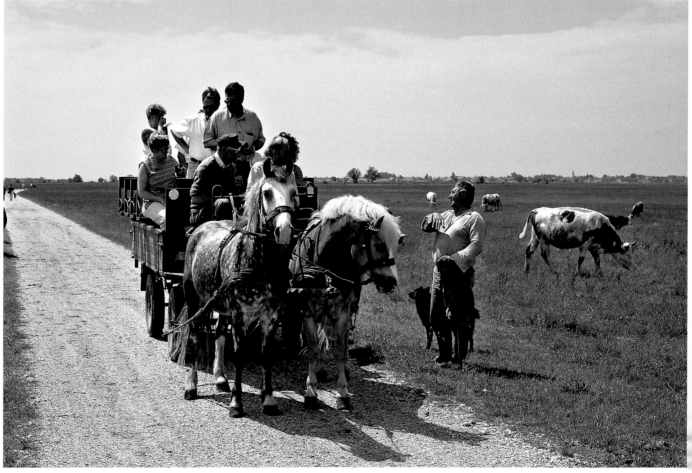

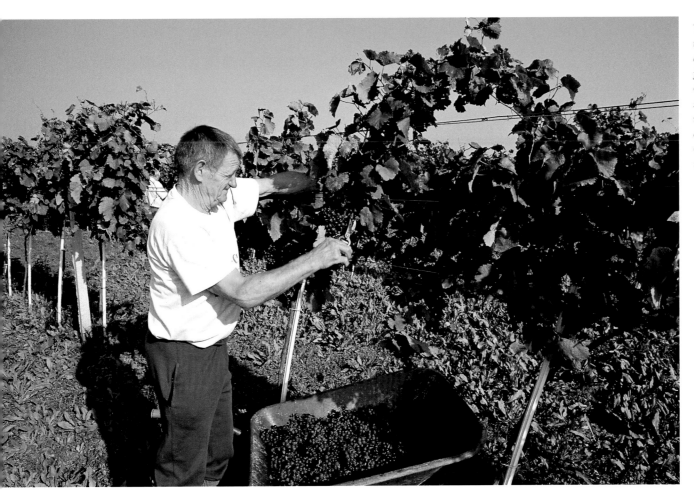

The Neusiedler See region is the warmest in the whole of Austria, providing favourable conditions for wine cultivation. Only specific varieties of grape may be grown here; one of them is Blaufränkisch which is being harvested in the photo.

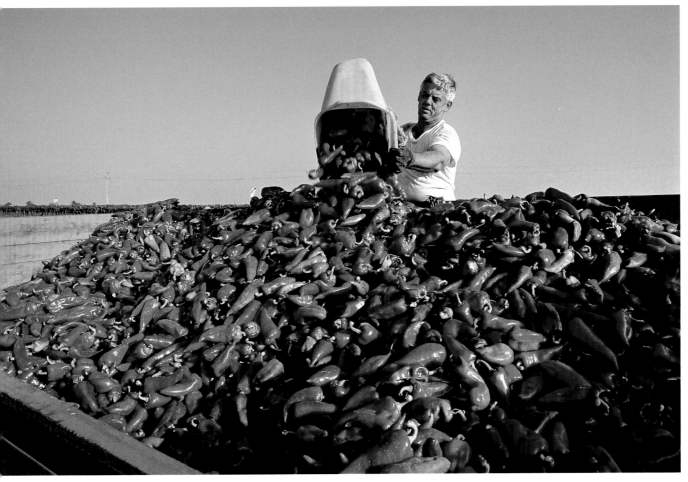

St Andrä is the main town in the Seewinkel, characterised by its old farmhouses with their ancient wells. It is also very close to Hungary, as this abundance of red peppers produced by the yearly harvest demonstrates.

87

Podersdorf on the eastern shores of the Neusiedler See is a lakeside resort with a reed-free beach, lots of wine taverns and a motor boat station. When taking a spin out on the flat and rather featureless lake the Podersdorf lighthouse is a useful landmark.

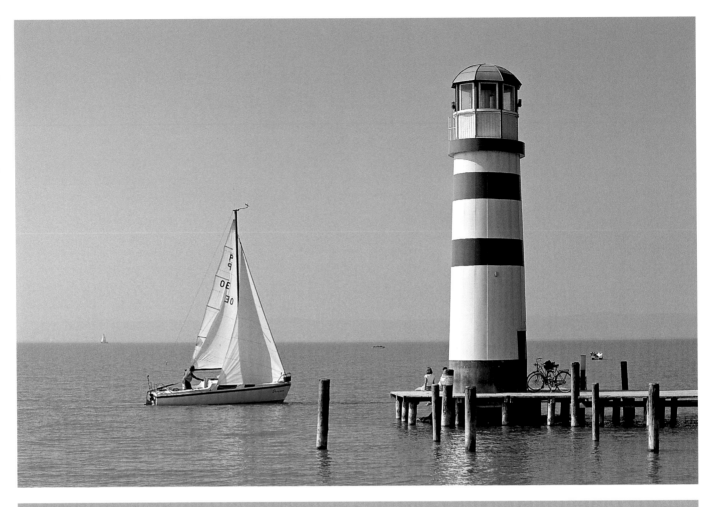

Mörbisch on the Neusiedler See is one of the biggest tourist destinations in the Burgenland. Its Seefestspiele, initiated in 1957, are famous in Austria and beyond and have earned the town something of a reputation as a mecca of the operetta.

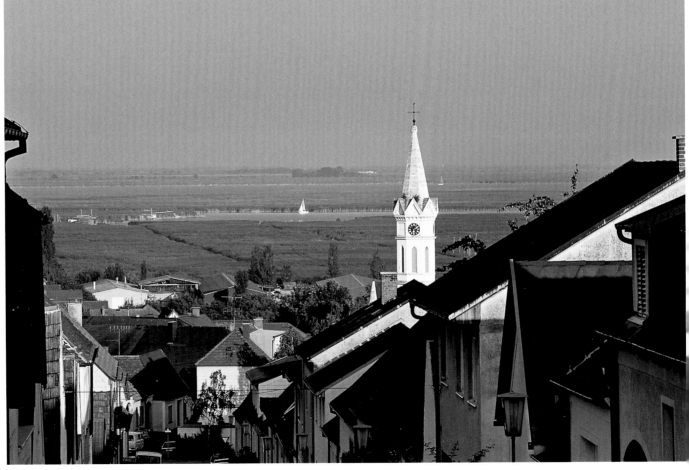

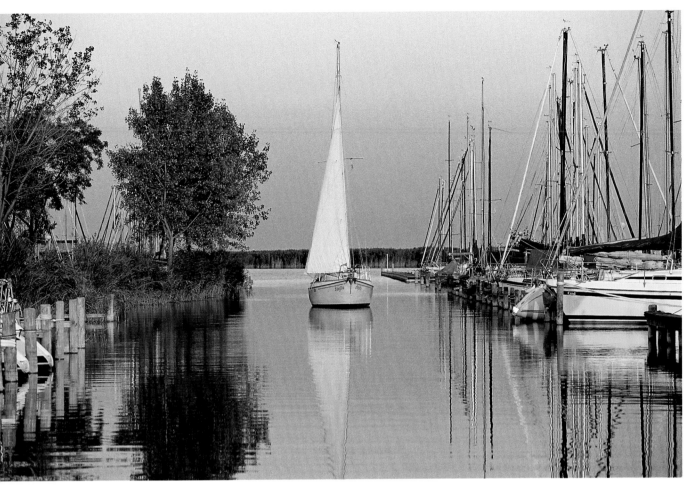

Mörbisch on the Neusiedler See has its own yachting harbour and also a school of surfing and sailing. Until 1921 the town was a German-speaking community belonging to Hungary. In the 'no-man's-land' between Austria and Hungary but on Hungarian soil is the Mithras Grotto, discovered in 1866 by Franz Storno with its relief from the 3rd century AD.

Rust is a popular tourist destination famous for wine on the western shores of the Neusiedler See. The town was made a royal Hungarian free city in 1681. The reedy shores of the lake provide over 250 species of bird with a natural retreat.

INDEX

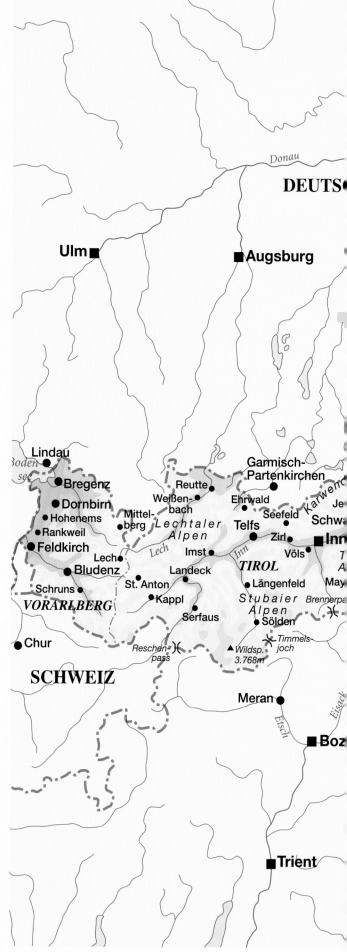

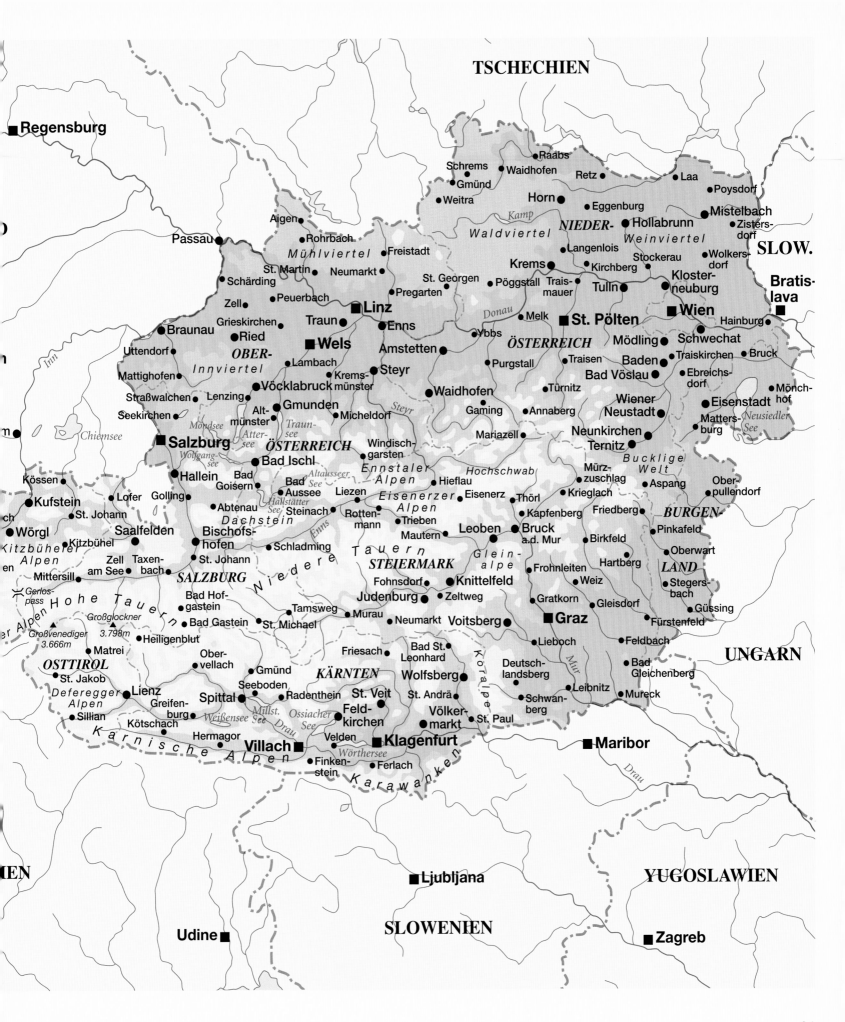

TSCHECHIEN

Regensburg

Raabs
Schrems
Waidhofen
Retz
Laa
Poysdorf
Gmünd
Horn
Eggenburg
Mistelbach
Weitra
NIEDER-
Hollabrunn
Zisters- **SLOW.**
dorf
Kamp
Weinviertel
Waldviertel
Aigen
Langenlois
Wolkers-
Passau
Rohrbach
Freistadt
Kirchberg
Stockerau
dorf
Mühlviertel
St. Martin
Neumarkt
Krems
Kloster- **Bratis-**
St. Georgen
Pöggstall
Trais-
Tulln
neuburg
lava
Schärding
Pregarten
mauer
Zell
Peuerbach
Linz
Donau
Melk
St. Pölten
Wien Hainburg
Braunau
Grieskirchen
Traun
Enns
Ybbs
Mödling
Schwechat
Ried
Wels
Amstetten
ÖSTERREICH
Baden
Traiskirchen
Bruck
Uttendorf
OBER-
Lambach
Purgstall
Traisen
Bad Vöslau
Ebreichs-
Mattighofen
Innviertel
Krems-
Steyr
Waidhofen
Türnitz
Wiener
dorf
Mönch-
Straßwalchen
Lenzing
Vöcklabruck
münster
Gaming
Annaberg
Neustadt
Matters- hof
Seekirchen
Alt-
Gmunden
Steyr
Mariazell
Neunkirchen
burg *Neusiedler*
münster
Micheldorf
See
Mondsee
Atter-
Ternitz
Chiemsee
see
ÖSTERREICH
Windisch-
Hochschwab
Mürz-
Bucklige
Salzburg
Traun-
garsten
zuschlag
Welt
Wolfgang-
see
Ennstaler
Hieflau
Aspang
Ober-
Kössen
Bad Ischl
Alpen
Eisenerz
Krieglach
pullendorf
Lofer
Bad
Bad
Liezen
Thörl
Friedberg
Kufstein
Hallein
Goisern
Aussee
Eisenerzer
Kapfenberg
BURGEN-
Golling
See
Rotten-
Alpen
St. Johann
Abtenau
Steinach
Trieben
Leoben
Bruck Pinkafeld
Wörgl
Dachstein
mann
Mautern
a.d. Mur
Birkfeld
Oberwart
Kitzbüheler
Saalfelden
Bischofs-
Schladming
Tauern
Glein- Frohnleiten
Hartberg
LAND
Alpen
Kitzbühel
hofen
Niedere
STEIERMARK
alpe
Weiz
Stegers-
Zell
Taxen-
St. Johann
Fohnsdorf
Knittelfeld
bach
Mittersill
am See
bach
SALZBURG
Enns
Judenburg
Zeltweg
Gratkorn
Gleisdorf
Gerlos-
Bad Hof-
Tamsweg
Murau
Güssing
pass
Hohe Tauern
gastein
Fürstenfeld
Alpen
Großglockner
Bad Gastein
St. Michael
Neumarkt
Voitsberg
Graz
Großvenediger 3.798m
Heiligenblut
Lieboch
Feldbach
3.666m
Matrei
Ober-
Bad St.
Deutsch-
Bad **UNGARN**
OSTTIROL
vellach
Friesach
Leonhard
landsberg
Gleichenberg
KÄRNTEN
Wolfsberg
St. Jakob
Gmünd
Schwan-
Leibnitz
Deferegger
Seeboden
St. Andrä
berg
Mureck
Alpen
Spittal
Radenthein
St. Veit
Koralpe
Lienz
Greifen-
Millst.
Feld-
St. Paul
Mur
Sillian
burg
Weißensee *See*
Ossiacher
kirchen
Völker-
Kötschach
Drau
See
markt
Hermagor
Villach
Velden
Klagenfurt
Karnische Alpen
Finken-
Wörthersee
Ferlach
stein
Karawanken
Maribor
Drau

Ljubljana
YUGOSLAWIEN

SLOWENIEN

Udine
Zagreb

91

The Mostviertel between the Danube, Enns and the Vienna Woods is well known for its pear must. Mild to fairly potent vintages are pressed from a variety of local pears, best drunk as a liquid accompaniment to a platter of local bread, cheese and sausage.

Front cover:
Top:
With the meadows in flower and the sky a deep Bavarian blue Oberndorf in Tirol is heaven on earth! This idyllic spot in the heart of the Kitzbühel Alps is practically unspoilt, providing a suitably celestial backdrop to the Corpus Christi procession held here every year.

Bottom:
Heiligenblut on the Groß-glockner-Hochalpenstraße is heralded as the most beautiful mountain village in Austria. Legend has it that East Roman field marshal St Briccius died in an avalanche here while carrying a bottle filled with the blood of Christ – hence the name "Heiligenblut" or "Holy Blood".

Back cover:
The provincial capital of Tirol is particularly scenic viewed from the bridge over the green waters of the Inn, with the Karwendel Range in the background. Innsbruck was once the Roman fort of Veldidena, founded at the point where the Brenner Pass cut down into the valley of the River Inn.

CREDITS

Design
hoyerdesign grafik gmbh, Freiburg

Map
Fischer Kartografie, Aichach

Translation
Ruth Chitty, Schweppenhausen

Printed in Germany
Repro by Artilitho, Lavis-Trento, Italy
Printed/Bound by Druckerei Uhl GmbH &
Co. KG, Radolfzell am Bodensee
© 2009 Verlagshaus Würzburg GmbH & Co. KG
© Photos: Martin Siepmann

ISBN 978-3-88189-665-8

Details of our full programme can be found at:
www.verlagshaus.com

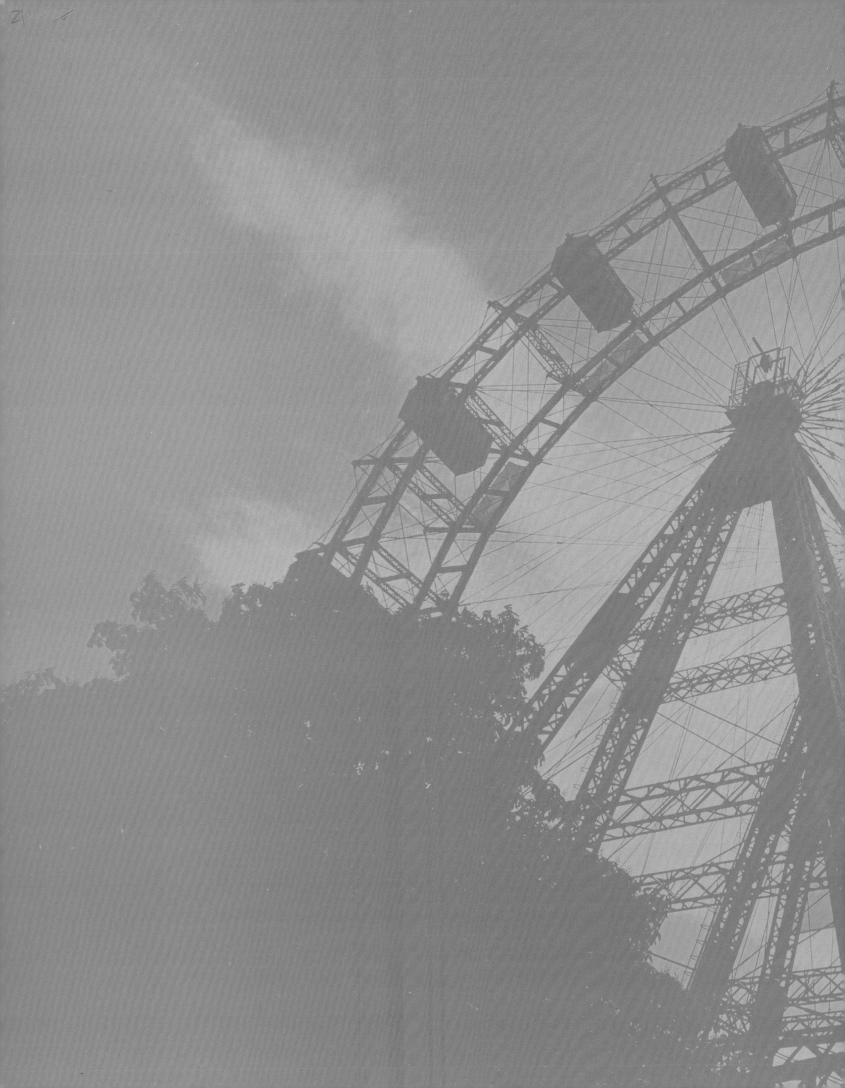